IMAGES
of America

MARLBORO
TOWNSHIP

D1200246

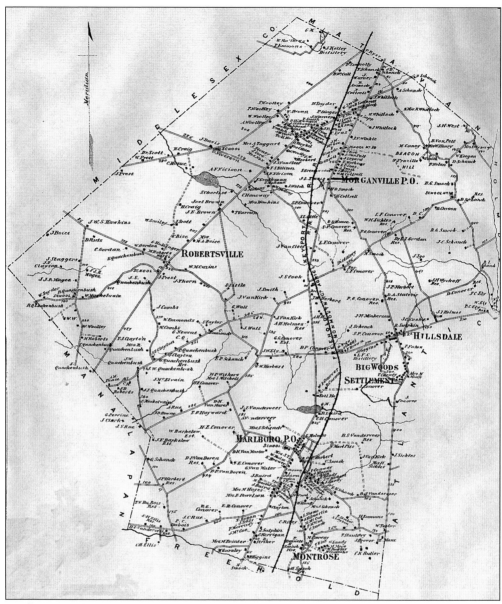

Marlboro on Plate 25 of the 1873 Beers Comstock & Cline *Atlas of Monmouth County* reflects settlement patterns in the township's first quarter of a century. An expanded view north and south would show the village's near central location between Matawan and Freehold. Morganville shows the greatest growth in the 25 years since 1848, likely due to proximity to Matawan, the bayshore's largest commercial center in the 1870s. Marlboro was the only post office preceding the township's incorporation; another, Morganville, was founded in 1870, while Robertsville enjoyed postal status only from 1862 to 1864. The township's third extant office, Wickatunk, was established in 1879, while Bradevelt was a post office from 1883 to 1916. Settlement also grew along a straightened and lengthened Tennent Road. Note the near-parallel route of the railroad (which has been known by many names) with the principal north-south road, the former Freehold and Matawan Turnpike, latter Highway 79, a not-infrequent occurrence in routing.

IMAGES
of America

MARLBORO TOWNSHIP

Randall Gabrielan

ARCADIA
PUBLISHING

Published by Arcadia Publishing
Charleston SC, Chicago IL, Portsmouth NH, San Francisco CA

Printed in the United States of America

Library of Congress Catalog Card Number: 2008940644

For all general information contact Arcadia Publishing at:
Telephone 843-853-2070
Fax 843-853-0044
E-mail sales@arcadiapublishing.com
For customer service and orders:
Toll-Free 1-888-313-2665

Visit us on the Internet at www.arcadiapublishing.com

This book is dedicated to Lora "Debbie" Tilton, a Marlboro resident and historian of long standing, who approaches her town's history with enthusiasm and knowledgeable skill in work with primary documents. Her generosity in securing and sharing made this volume a better book and her cheerful assistance enhanced the joy of its writing.

CONTENTS

ACKNOWLEDGMENTS

The participation and assistance of Lora "Debbie" Tilton (see page 4) in the securing of images, for her historical knowledge, and as a community resource was of incomparable value, for which I express my deepest thanks and appreciation. I also thank her mother Emily, who has a long memory, familiarity with Marlboro history, and a willingness to share that information.

The aid of families with a farming tradition, who provide an extended look at a town's agrarian past, is particularly appreciated. Special thanks to Ruth Alt, Helen Crine Mahon, Charles Meglio, Rhea and Aileen Preston, and Pierre D. Van Mater III.

The Sisters of the Good Shepherd are loving custodians of what is arguably Marlboro's most historic property. They fulfill a special spiritual and educational mission and shared generously from their archives. Thanks to Executive Director Sister Ellen Kelly and Sister Dorothy Ryan.

Many postcard collectors have supported my writings. John Rhody's long-term, helpful assistance was again repeated for *Marlboro Township*. I am pleased to acknowledge and thank Harold Solomon for his considerable help, particularly for the cover picture.

The incomparable breadth of the collection of Photography Unlimited by Dorn's, Red Bank, reaches Marlboro. I give thanks and appreciation to them and Kathy Dorn Severini for long-term support and assistance.

Thanks to Brian Donohue of the *News Transcript* whose journalistic boost near the end of this project helped make a good book even better. Thanks to Mary Ann Kiernan of the Monmouth County Archives for securing documentary material from that remarkable resource.

Thanks to all the lenders of pictures, which comprise a rich and diverse collection; you are the co-producers of this work. They include: Helen Alt, John Becker, Olga Boeckel, the Collins family, Elizabeth Costic, Sarah Ann Herbert Ebentheur, Leslie Eckert, The Fariello family, Helen LeMoine Guth, Barbara Hess, Marie Miles Holmes, Gail Hunton of the Monmouth County Parks System, Gloria Janwich, Mary Ann Burke Ker, John Lentz, William Longo, Dorothy Ann McCue, Martin and Theresa McCue, the Monmouth County Historical Association, Juanita Farr Montgomery, Robert Nivison, Mabel Stattel Preston, Frank Ratcliffe, Rutgers University Libraries, Special Collections & Archives, St. Gabriel's Church, the Stattel family, C. Elizabeth Stevenson, Jeannette Higgins Thompson, Colleen "Pat" Vanderveer, Henry Waplehorst, and the Werbler family.

INTRODUCTION

Marlboro was incorporated in 1848, founded by a legislative act signed by the governor on February 17. It was a decade when most large, "original" townships were divided for administrative purposes. Marlboro's organizational meeting was held March 14, 1848, at John F. Sutphen's hotel to elect officials and draw a budget for the following year. John C. Smock became town clerk, while the township's first two freeholders (who were elected by municipality then) were John W. Herbert and Garret D. Schenck. Roads, schools, and caring for the poor were the principal expenditures, in Marlboro and elsewhere at the time.

Marlboro was a village before the municipality was organized. It appears to have been a crossroads settlement, one that sprang up with little documentary record. Previous works on Marlboro have claimed it was earlier known as Bucktown. However, search has not revealed either a documentary or map reference with that name. The record does show a Bucks Tavern, which originated in the 18th century, the apparent focal point around which the village grew.

Mid-19th-century maps of Monmouth County show Marlboro nearly halfway between Freehold, the county seat, and Matawan, a key bayshore commercial center, and, until the prevalence of steam, an important dock. The stature of Bucks Tavern, the antecedent of the hotel on page 83, as a stage coach stop is noteworthy as it enhanced the significance of the local hospitality site, one being necessary in sparsely settled areas and even mandated in colonial times. The stage stop likely facilitated nearby growth.

Rural townships were often the sum of their local settlements, or villages. Map research reveals little early evidence within the boundaries of the future Marlboro Township. The first significant work of New Jersey geography, Thomas Gordon's 1834 *Gazetteer of New Jersey*, merely contains scant reference to Barrentown, "some 6 or 7 dwellings in a poor, sandy soil," located on the road from Freehold to Middletown (in the vicinity of School Road East). However, Gordon missed Marlboro village, where an emerging settlement justified opening a Marlboro post office in his year of publication.

The first significant map of Monmouth County, surveyed by Jesse Lightfoot and published in 1851, adds Hillsdale to Marlboro village and Barrentown, but shows a rural land with its population centered at its crossroads and scattered elsewhere.

Marlboro did contain large, productive farms. Indeed, they were the principal taxpayers in the early years. Shortcomings in its soil were enriched by application of marl, the namesake material that is a grainy substance of decayed animal and plant life, which was discovered locally in the 18th century. Old mills, local operations which ground their surrounding farms'

grain production, are often a guide to settlement patterns. One within the present township left pictorial evidence. It was located a short distance north of the village, virtually on its principal road, and is pictured on page 97, but needs additional research to reveal its history. Another, Van Dorn's, served Pleasant Valley and is now on the Holmdel side of the township's border. Slight evidence indicates the apparent existence of other mills, which also require additional research.

The book is organized by topic, with the intent to present a representative collection within each chapter. Although there is no chronological order, each chapter presents a broad perspective of its subject, with the captions conveying the information about the organizations, places, and events that gave character to the township. As a rural municipality for most of its existence, farms and residences are given the largest space. They are rich subjects that are nowhere near exhausted by this work.

The collection of pictures for this work contained a fine overflow, a great springboard for another volume, which could be published if this one is a success. Any book of this nature will contain omissions, generally resulting from a lack of imagery, or a lack of space. The author hopes those shortcomings will be remedied with another book and will continue to collect pictures to such aim. Potential lenders may reach me at 71 Fish Hawk Drive, Middletown New Jersey 07748, (732) 671-2645.

Home Sweet Home

The evocative landscape, merely labeled "wickatunk 1907," provides little hint of identification for a changing landscape, a nostalgic reminder that the search for local history can be elusive. (Collection of Harold Solomon.)

One

THE DOMESTIC SCENE

FARMS AND HOUSES

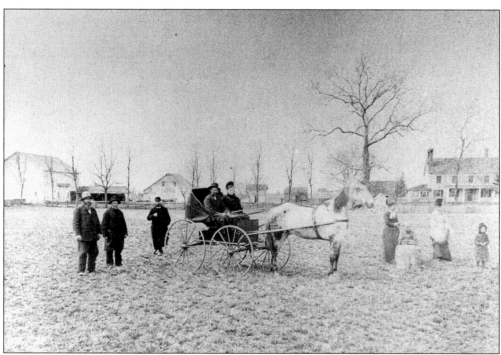

The Walls' Buttonwood Farm, named for its trees, faced County Road 520 and is pictured *c.* 1900, its subjects unknown. Surrounded by development, it stands, with its site now known as 1 Farm House Road. This old house received its prominent position for having been preserved on site, with the new construction designed around it. As long as loss of farms persists, preserving their houses on site is one of the greatest preservation needs, a matter that should be influenced in the planning process.

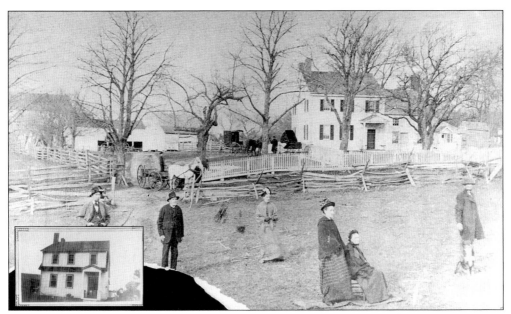

Adolph Menzel bought in 1924 a former Clayton family farm around Church and Gordons Corner Roads. He was born in 1896 and married Laura Kvist in 1928. The farm is pictured c. 1890, the subjects perhaps unidentified Claytons. The main block appears to be a mid-19th-century expansion of an 18th-century one-and-a-half-story house on its right. The house, remodeled in 1928, is seen in the inset, photographed in 1937. Menzel sold the farm c. 1969, while the house was destroyed for development c. 1969. He died in 1984.

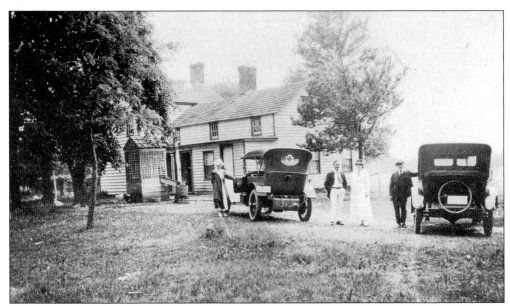

Emil Henry Menzel, born 1893 in Old Bridge, New Jersey, bought in 1917 a farm on the west side of Church Road, at Gordons Corner Road, consisting of 30- and 50-acre parcels. The house is pictured in 1918, prior to the raising of the upper level to a full story c. 1935 (seen at opposite).

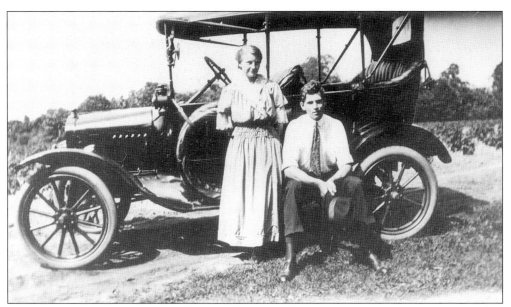

Emil Menzel married in 1918 the former Florence Mae Hawkhurst, who was born in 1896 in Brooklyn; she lived on Staten Island prior to moving to Old Bridge. The two are pictured, perhaps that year, she attired in her wedding dress.

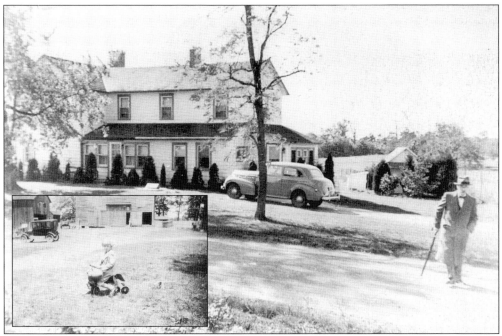

The Emil Menzel house is pictured in 1939; at right is a structure that once housed farm help, later becoming daughter Emily's playhouse. She is seen in the inset riding an articulated dachshund, a German import. Labor on the farm was also hard work, as Emily remembers holidays such as Memorial and Independence Days spent in the strawberry and raspberry fields respectively.

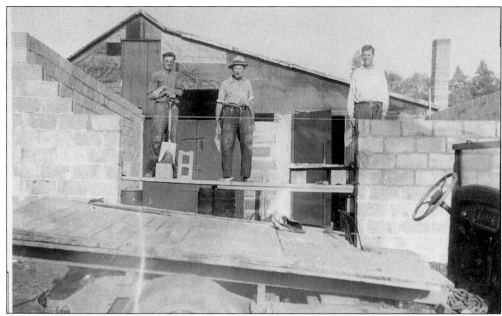

Emil and Adolph Menzel combined their farming operations, trading as Menzel Brothers. They are at right and left respectively, flanking mason Paul Hauser, their uncle, in a 1932 picture showing the construction of a produce storage warehouse. The business specialized in peaches and apples in its later years.

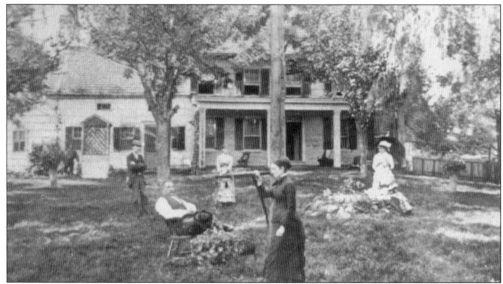

The Jacob Van Dorn house on the north side of County Road 520 has its origins in a one-and-a-half-story section on its west, perhaps dating from the 1730s. Its main block is a five-bay, two-and-a-half-story Georgian-style structure perhaps dating 1753. This historic view, subjects and date unknown, provides a glimpse of the rear of the house lot, showing a well and an apparent utility pole. If one is inclined to think of a century ago as the good old days, remember how often they overdressed. At least the seated man took off his jacket. (Monmouth County Park System-Historic Sites Inventory.)

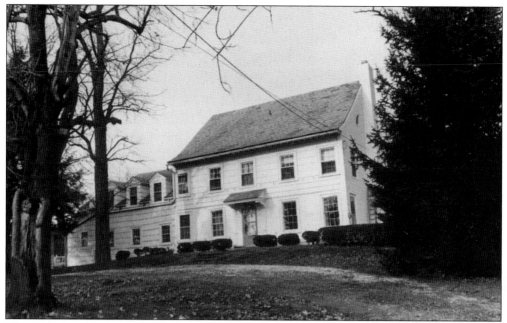

The property is part of the Jacob Van Dorn Sr. 675-acre tract purchased *c.* 1697. The house, built by Jacob Van Dorn Jr., facing south, is pictured in 1981, and has been altered in various periods. It shows changes from the Colonial Revival, including, on the wing, additions of three dorners and removal of its old door and former knee-wall windows. The door of the main block is a replacement, as is the external chimney. (Monmouth County Park System-Historic Sites Inventory.)

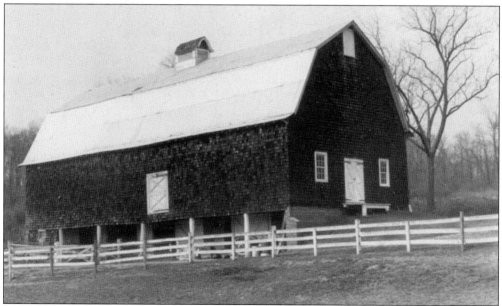

The sizable barn appears to be a type commonly built in Monmouth County in the 1920s and 1930s. In 1690, Van Dorn established a mill nearby, now on the Holmdel side of the border, a reminder that local history has many links spanning later municipal lines. (Monmouth County Park System-Historic Sites Inventory.)

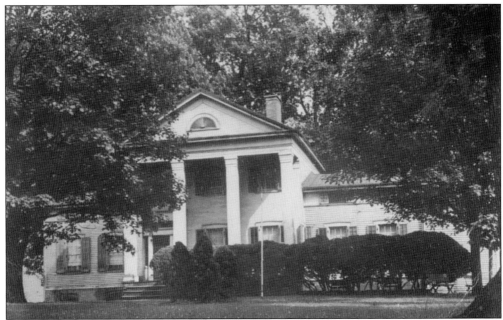

This house, formerly on the southwest corner of Pleasant Valley Road and Igoe Road, was widely known as the Gordon Farm for Dr. Lewis I. Gordon, who conceivably could have built this rare example of a rural Monmouth County temple-form Greek Revival house. Earlier owners were Garret and Denise Hendrickson (married 1808), possible builders of the original house, which was older than what this image of the facade projects. The house, pictured in 1944, was in deteriorated condition for some time prior to its being taken down in the 1990s.

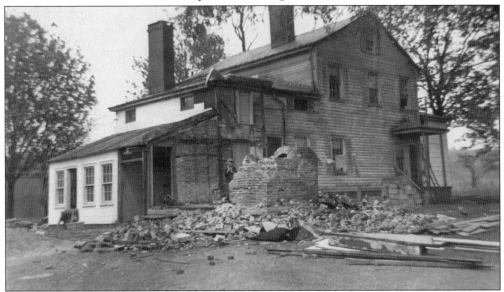

Clyde Vreeland Ronson bought the Gordon farm in 1944. His family desired more modern kitchen facilities and in 1946 demolished the old kitchen with a beehive oven. This picture demonstrates that the house pictured at top was built around and incorporated at least some of an older structure. Building, while saving the older house, is an ongoing preservation issue, one that was embraced here about 150 years ago. Regrettably, even the "newer" place is lost now.

Lafayette Conover, born 1822 in Marlboro, married Elizabeth Schenck in 1846, the year he moved to Middletown, where he farmed for two years. He returned to Marlboro in 1850, buying his father-in-law's farm in Pleasant Valley, located next to his brother Stacy P. Conover. Lafayette farmed, operated a distillery, and was active in public life, serving as Monmouth County freeholder for seven years and on the committee that rebuilt the courthouse (the present Hall of Records). He was active politically, having been a member of Marlboro's township committee and a township collector. Conover was a major donor of the Old Brick Reformed Church and a director of the local railroad. He was widely admired and respected at his death in 1901. (Portrait from Ellis, *History of Monmouth County*.)

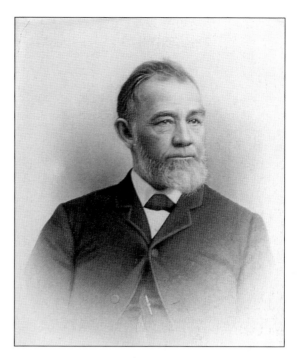

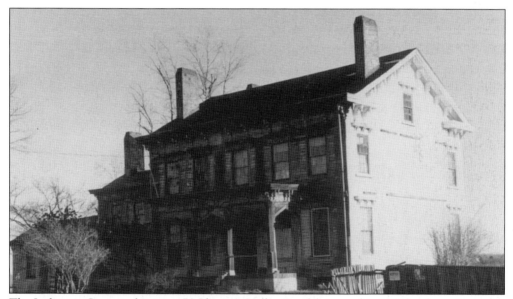

The Lafayette Conover house at 72 Pleasant Valley Road (pictured in 1981), a large, two-and-a-half-story Italianate five-bay main block, with a one-and-a-half-story wing on the east and a lower ell, probably dates from the 1860s. It was arguably the largest and grandest house in the township when new, reflecting the ambitions of a prosperous farmer. The foundation is brick and its lumber is machine cut (some hand-joined), which, combined with his personal profile, tends to refute earlier dating. The house was described in Conover's obituary as "large and of commanding appearance and the outbuildings and grounds are kept up in fine shape." They still are, thanks to a careful, extensive restoration in the recent past by Carol and James Fluhart. (Monmouth County Park System-Historic Sites Inventory.)

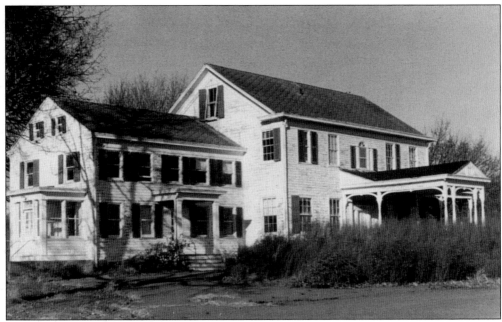

The Stacy P. Conover house as pictured in 1981 reflects late-19th-century alterations to a Greek Revival period, possibly 1850, house. The wing at left is a later addition. Stacy (brother of Lafayette, page 15) was a large property owner and major figure in 19th-century Marlboro. His house on the west side of Conover Road (about one-fourth of a mile north of Pleasant Valley Road) was damaged by fire c. 1990; the remains were demolished. (Monmouth County Park System-Historic Sites Inventory.)

The Stacy Conover barns present an infrequent instance of barns out-lasting the house of their respective farm (see top). Stacy reportedly bought this farm in 1862, located near his ancestral dwelling house, where he was born in 1828. Tracing the extensive Conover holdings in Marlboro necessitates following a trail made obscure by numerous family members and many properties with no longer standing structures. (Monmouth County Park System-Historic Sites Inventory.)

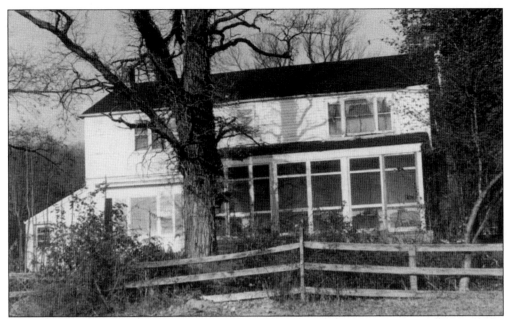

This *c.* 1767 house built as one story by John Reid and sold shortly thereafter to Captain John Schenck is obscured by 20th-century alterations. Captain Schenck was a militia officer in the Revolution known for his daring exploits. The farm remained in his family into the 20th century. Schencks, who owned other nearby farms, were among Marlboro's largest property owners. (Monmouth County Park System-Historic Sites Inventory.)

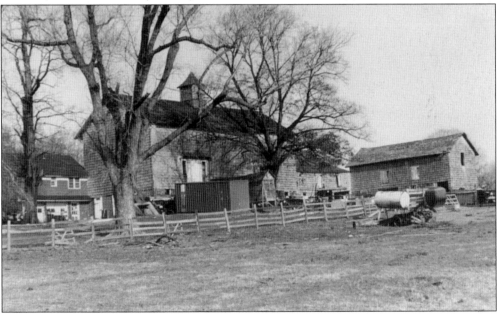

The house is at left in this view looking north of the barns and paddock area. The smaller barn at right is older, dating from the late 18th or early 19th century. The two-and-a-half-story English-style barn was likely mid-19th century. The complex, located on the east side of Pleasant Valley Road, about three-fourths of a mile north of Schanck Road, appears to have been lost to housing development. (Monmouth County Park System-Historic Sites Inventory.)

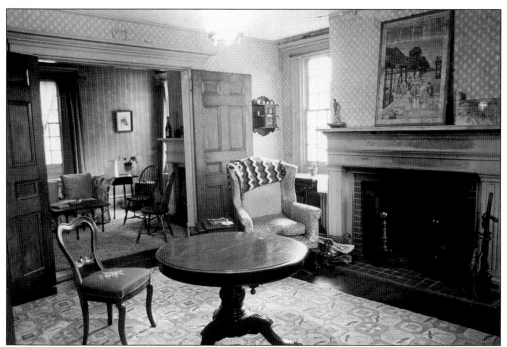

Colonel Asher Holmes was one of New Jersey's most distinguished Revolutionary-era patriots. His 1774 appointments on the Committee of Correspondence and the Committee of Observation and Inspection pre-date the war. He commanded several units of soldiers and saw extended action throughout the war. He settled in the Pleasant Valley area and lived out his life in Marlboro. The living room of his house is seen in the 1970s.

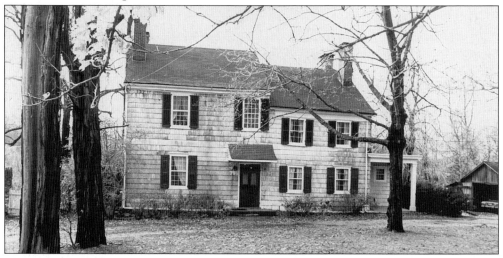

The Colonel Asher Holmes house at 268 Pleasant Valley Road, with 18th-century origins, appears to be built in two main sections. Nicknamed "Old Kentuck" (origin unknown), it is Marlboro's only property on the National Register of Historic Places, listed in 1973. The house is vacant at time of publication (August 1999), boarded-up, while a demolition permit has been issued. Its destruction would be a grievous loss to Marlboro's historic patrimony. One can only hope that hope for it remains and that significant historic properties get directed to the right owners who will care for them.

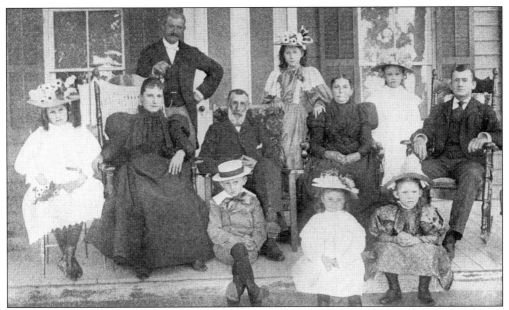

Asher H. Holmes (a grandson of Colonel Asher Holmes' brother) and his second wife Margaret, sister of his first wife Sarah, are seated in the center of this family portrait. To his right is his daughter Sarah, while son-in-law Ferd Vreeland stands over her. Their children (seated), from left to right, are Florence (on the chair), Asher, Viola, and Margaret. Their son-in-law William F. Cutter is at far right. His wife Mary died prior to this picture, but their children Margaret and Sarah stand on their grandmother's right and left respectively.

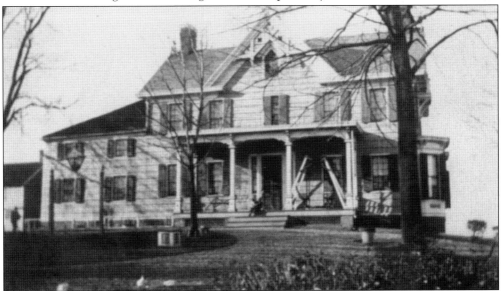

The Tylee Schanck house on the west side of Highway 79, south of the De Fino School, contains a datestone with the owner's name, the date May 1, 1833, and the names of mason Joseph I. Perrine and carpenter William Warren. The Federal-style house was altered in the later 19th century with the addition of the ell on the left, center gable, porch, and bay windows. It was later owned by Asher H. Holmes, part of his 113-acre farm. The horse chestnut tree in the center is now as high as the house.

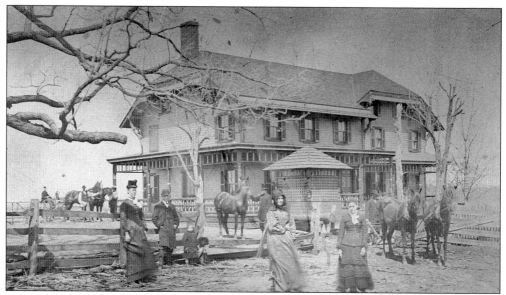

James P. Crine, son of Michael (page 90), was born in 1863 and began to buy farm property *c*. 1903. The subjects and occasion of this *c*. late-19th-century photograph are unknown, but perhaps they could dress up for the camera during winter, the farm's period of lesser activity. The image reveals a large house built in two major sections, begun perhaps *c*. 1870s and located on Crine Road.

James P. Crine is in the center of this *c*. 1930 group. James was a popular Christian name in the Crine family, given to both youths here, including James Charles, son of James Kelly Crine at left, and James David, son of William Crine. The Crine men are, to James P.'s right, John Kelly and Michael L. Crine; to his left are James P. (his son) and William H. Crine. Michael and the younger James P. did not marry, but remained on the farm.

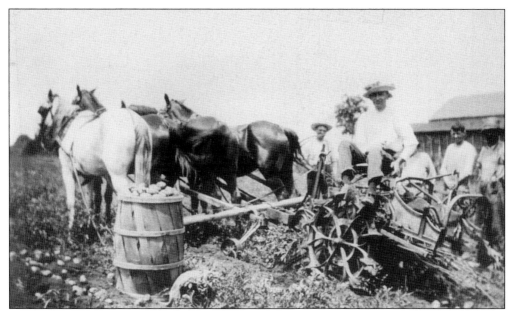

"What else did you expect an Irishman to grow?" was Helen Crine Mahon's joking response to an inquiry on the Crine farm's output. Actually, Monmouth was once the nation's leading potato producing county, so it was an equal opportunity crop for all the county's ethnic mix. The four horses appear hitched together, so presumably a very heavy load was expected.

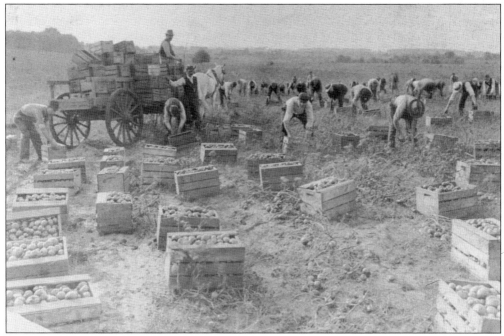

The period before World War I was the peak for potatoes in Monmouth County. The war's manpower shortage dealt a blow to all agriculture here, while depressed potato prices in the 1920s led local farmers to consider other crops, including grapes, a proposal that never took wide hold. The boxes appear ready for shipment, so presumably the potatoes were graded as they were packed.

The youthful Helen Crine Mahon provides witness that the Crine farm also raised turkeys. (In a gesture suggesting the repetitive nature of history, a wild turkey appeared on the author's lawn the August 1999 day this caption was written.) At left is her grandmother, Mary Kelly Crine.

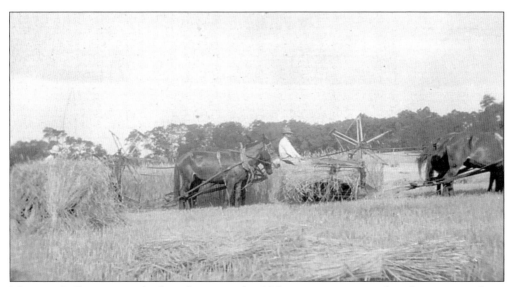

Monmouth County raised a lot of grain in the 19th century, an agricultural practice perhaps not widely known. The farmer had no preordained loyalty to any crop. Their choice of planting was driven simply by the cost of raising it, including seed, labor, and fertilizer, compared with market yield. Economics motivated the Monmouth County switch from grain to potatoes, including the concentration of milling in large midwest milling centers.

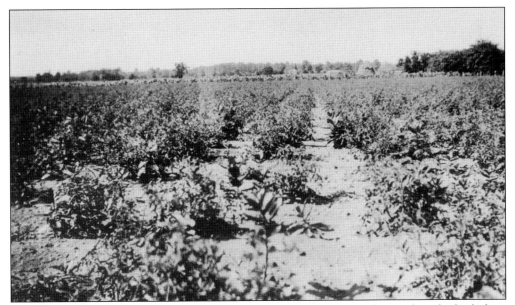

James Crine farmed his land until his death in 1936, a time when the markets for both farm land and potatoes were depressed. His family continued the operation, but on a diminished scale. James is believed to have accumulated 217 acres, which was sold over time. His daughter Ellen, known as Nellie, born in 1910, oversaw most of the dispersal, surviving until January 1996, when she owned ten acres.

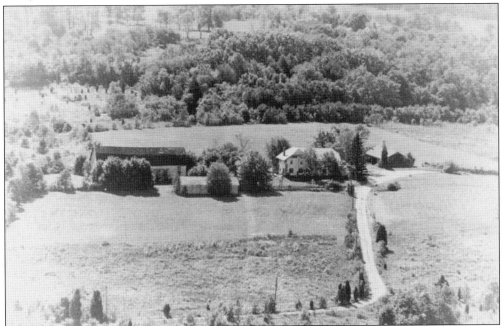

This aerial, perhaps c. 1960s, shows the house on the top of page 20 in relation to farm buildings, along with front and back drives. Housing appears to be the ultimate "crop" of the Monmouth County farm. The house was demolished in 1997 for development. Indeed, the author saw some houses "growing" here during the summer of 1999 production of the book, an experience not among the season's top ten aesthetically pleasing events.

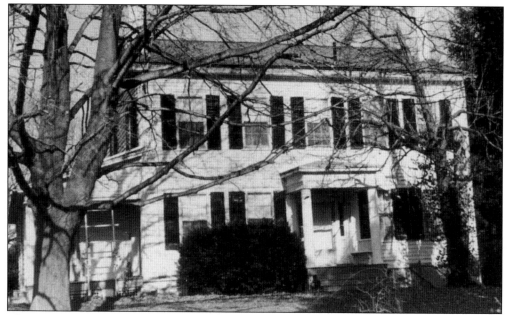

The c. 1840s Greek Revival Uriah Smock house on Vanderburg Road, east of Highway 79, has similar facades on both south and north, the latter closer to today's fronting street, Vanderburg Road, the former facing, but located some distance from, the earlier thoroughfare, School Road East. The surrounding property is reportedly the site where an Irish immigrant farm worker discovered marl in 1768. It is the natural fertilizer that was so important to early agriculture in Monmouth County. (Monmouth County Park System-Historic Sites Inventory.)

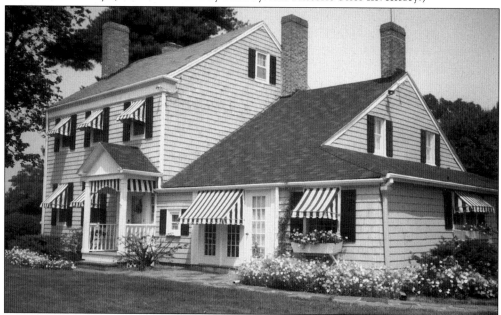

A newer entrance obscures the original walls and door of the 18th-century origins on the east side (right) of the old farm at 107 Vanderburg Road. The two-and-a-half-story main block on the west is a likely first half of the 19th-century addition. A surviving old barn helps suggest the lay-out of the ancient farm the property represents.

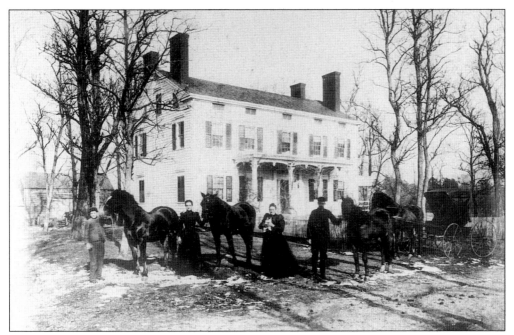

The original photograph is marked "Old John Wall farm"; it is believed to be the place north of County Road 520, west of Gordons Corner Road. The house, no longer standing, probably dates at least from the first half of the 19th century and was likely built in two major sections. The occasion of the winter animal parade is also unknown.

A Conover farm on the north side of Ryan Road is pictured, perhaps late 19th century. The second farm west of Highway 79, it was owned for a time by Holmes R. and Mary Jane Conover. Housing is on the site now; the buildings disappeared c. 1950s.

The foreground of this c. 1950s aerial portrays much of the farm described under the next two photographs. A barely perceptible line under the dark middle ground marks its eventual division boundary. Highway 79 runs diagonally across the center, the site of most of the pictured buildings. In 1999, the center area is the site of two cemeteries, the one on the east side being under construction. Beacon Hill is in the center background, while the former Lavoie plant is in the left background.

William Edward Preston, born 1867 in Old Bridge, was educated in Middlesex County and first employed as a butcher in an uncle's shop in Brooklyn. He later entered the butcher business with his brother John in Perth Amboy, the two selling it in 1908, the year William bought a Marlboro farm. Preston married the former Minnie Holmes, the two becoming parents of nine children, including Howard (see page 111) and Rhea, the lender of this 1961 photograph. William, who served many years on the Marlboro Board of Education, is remembered by Rhea with a respect and admiration that would make any parent proud. He died in 1965.

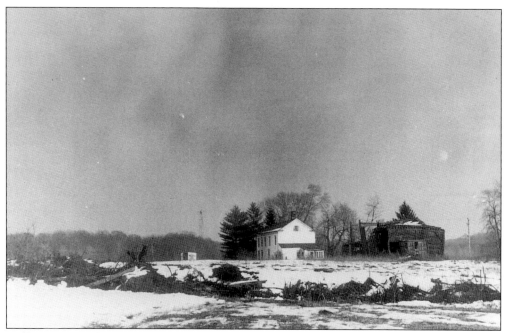

William Preston bought a 132-acre farm from Clara Tunis in 1908, located in Morganville on the west side of Highway 79. The still-standing house is pictured in 1956 after a violent storm, which Rhea recalls as an undeclared tornado, destroyed the barn at right.

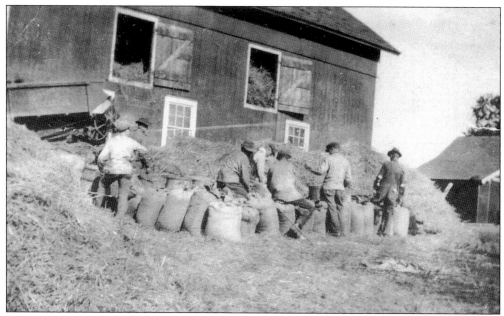

Preston's crops included wheat, seen here in a 1924 threshing scene picturing Rhea, at left, at age 12. He recalls that John McCormick, the local owner of a thresher, would visit many area farmers for the threshing operation, reflective of a time when the local farming community was infused with a strong practice of mutual help.

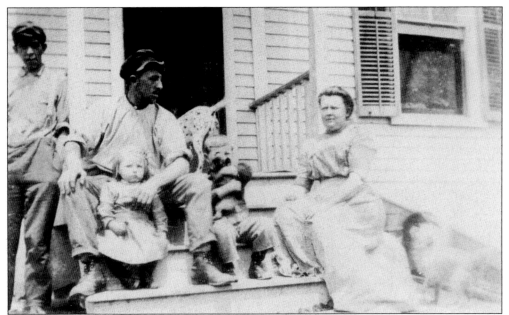

John H. Becker, a German immigrant, came to Morganville from Brooklyn in 1892 or 3, began farming and established an extensive greenhouse operation. He lived on the west side of Highway 79 in a house purchased with the Mary E. Leynes farm in 1895. It is the scene of this *c.* 1910 picture of his nephew J.B. Becker (holding Ann Loretta) and Anna Schenking Becker, his wife. Also present are his sons, Joseph Becker, left, and Louis Henry Becker under the dog. Becker's two nephews, J.B. and Henry, would take over the business following the elder Becker's death in 1930, by which time Becker was a 90-acre operation.

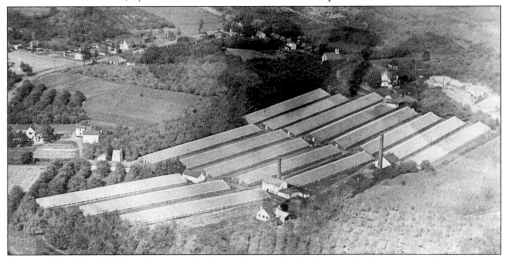

The Becker Morganville greenhouses are pictured in the 1930s. Eight were built in the 1890s, while an additional eight were erected in the early 20th century. Vegetables were grown in the greenhouses; the farm's output included carrots, beets, tomatoes, corn, lettuce, string beans, and apples. The place used a Highway 79 address, the road in the background; the location is discernible by the presence of Tennent Road, the diagonal line at left. The property was sold and the greenhouses were buried on the site in the 1970s. The land has not been developed and is being unintentionally reforested.

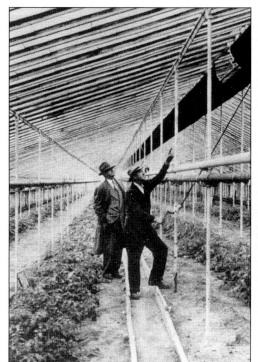

M.B. Ulrope, Esso representative in New Jersey, is seen pointing at a screen impenetrable by insects in a Becker greenhouse, with J.B. Becker, standing in front of a growing tomato crop. Becker cucumbers received two patents. Among their specially bred qualities was the straight shape. They were grown only in greenhouses, were typically 14 inches long, and were always laid out six across.

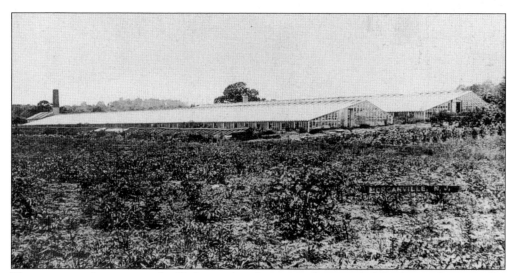

The two greenhouses may be Dickinson's, who not only preceded Becker to Morganville, but suggested the place as Becker was planing a move from Brooklyn to escape its rising taxes, pointing out the proximity of the railroad. Becker had its own siding. The Merriman photographic postcard is *c.* 1910.

Fred von Rodeck, born in 1892, was an accountant who married Gladys Gwynne Lothrop in 1914. He bought a 21-acre farm from Alfred Woolley in 1929, coined its name, Eden Farm, using it initially as a summer place. It was located on the west side of Highway 79 on Brown Road. Farming was not Fred's only interest, as the adventuresome soul prospected for gold in New Mexico in 1932.

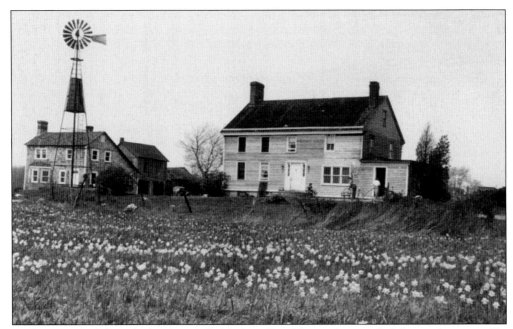

Fred von Rodeck brought his first daffodils from Brooklyn and expanded their cultivation. He also grew gladiolus. The von Rodeck daffodils were used in landscaping the new Garden State Arts Center. The farm was divided in two after his death. One course of the division line is suggested by the unpaved section of Brown Road. The house faces that road, standing today little changed. The windmill, built in 1905, was lost in a mid-1950s hurricane.

Other crops were tried on the von Rodeck place with Irving Hartig and Fred von Rodeck seen cultivating cabbage in the 1930s. Daughter Ruth von Rodeck Alt was pictured in the gladiolus field c. 1930.

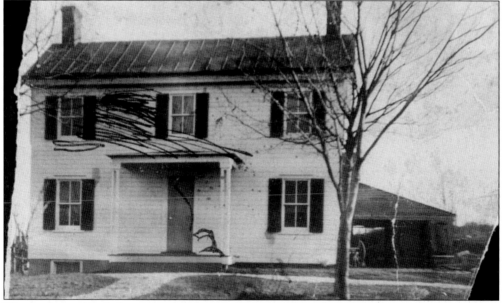

This traditional-style house at 111 Tennent Road, perhaps dating from the 1860s, was earlier owned by J. Stryker and sold by Alfred Stryker in 1890. It has been expanded more than once, including the addition of a wing on the rear. Part of the house was used as the Morganville post office early in the term of postmaster Lillian Slover, until she erected during the late 1940s the building seen on page 109. Her successor as postmaster, Ruth Alt, and her husband Joseph D., bought the house in 1956 and still live there. The place is readily recognizable, although sided, absent the barn and has its second-story center window covered.

31

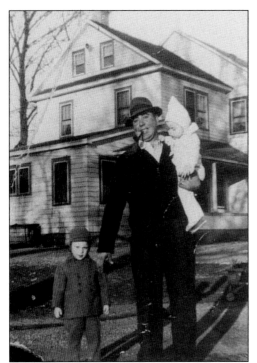
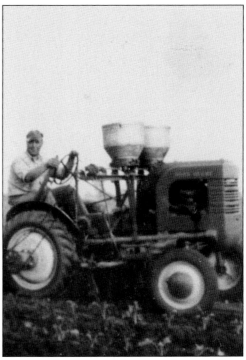

John Meglio was the founder of the family farm, moving here out of the way of approaching development along southern Flatbush Avenue in Brooklyn. It was located on the north side of County Road 520, east of Highway 79 and was continued by his son Joseph. The younger Meglio is seen with his sons John, at his right, and Charles (the lender of the photographs), in his arm. He is seen again at right c. 1946 on a tractor equipped to cultivate and fertilize simultaneously.

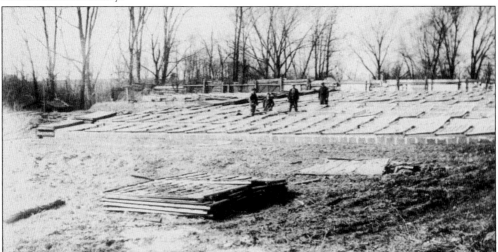

John Meglio built his hot boxes of terra cotta in lieu of the commonly used wood, preferring the permanence of the material. The hot box is a halfway house for seedlings, between the greenhouse and the field, the cover providing protection against spring chills. The durable material can be found in ruins in the woods adjacent to the Marlboro Shopping Center, now sprouting maturing trees.

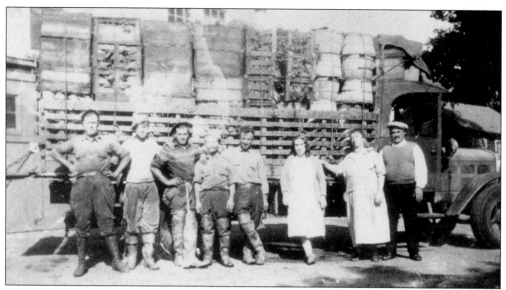

The Meglio farm obviously had a skilled truck loader and avoided routes with low overhead bridges or trestles. This truck is filled with greens, the farm's output including cabbage, celery, and lettuce.

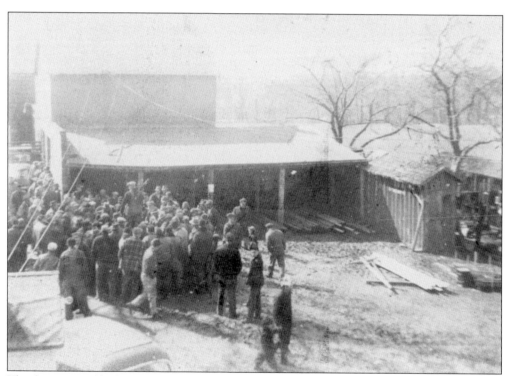

The farm was sold after Joseph Meglio's death in 1947 and its equipment was auctioned. The country farm auction in the area's heyday of agriculture was a major event, both social and business. The prices realized were often a measure of the current value of farming. Sadly, the auction could also represent a family's aspirations prematurely cut short.

David and Marion Werbler, from Newark, began egg farming in Marlboro in 1953, in conjunction with his sister and brother-in-law Sam and Frieda Striks, who arrived in 1951. It was their first effort at agriculture, at the height of a period when numerous Jewish chicken farmers were making southern Monmouth and northern Ocean Counties egg country. David is seen c. 1955 at left with his elder son Dan. His father Israel is at right with younger son, Jack. David and Marion relocated to Lakewood after the property was sold, David having become first an egg distributor and then a land investor.

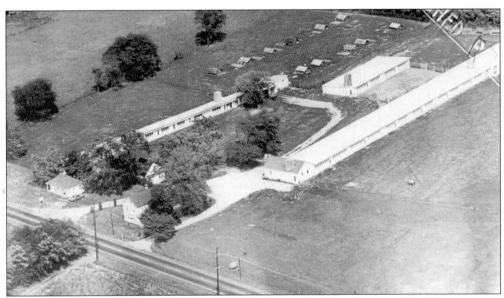

Highway 79 runs along the bottom of this 1950s aerial. The Werblers remodeled the two-and-a-half-story farm house in front and built the chicken buildings. The egg building was the side-gabled building in front of a long chicken house. The farm had a roadside stand, and made deliveries to other road stands and diners. The farm, in the planned roadway of Highway 18, was taken by the State for that project; all the structures were demolished c. 1970.

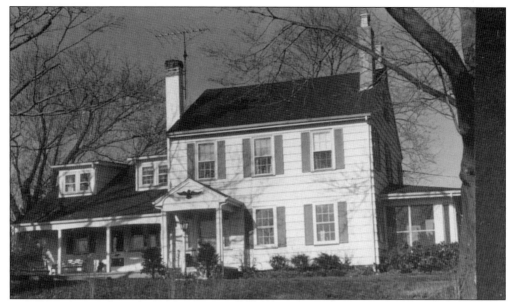

This house at 99 School Road West has possible 18th-century origins on the west, with the main block at right a 19th-century addition. It was the parsonage of the Dutch Reformed Church for some decades dating from 1826. Daniel H. Van Mater bought the place c. 1860s, and it is the probable start of the family's well-known dairy. (Monmouth County Park System-Historic Sites Inventory.)

This Greek Revival farm house, perhaps dating from the 1840s, was on the Van Mater Joceda Farm when moved from the east side of Highway 79, c. 1971. Formerly located on a site near a planned Highway 18 ramp, the house now stands on Willis Street in Marlboro village.

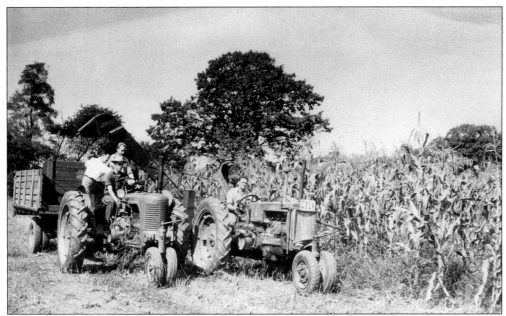

Van Maters had been in Monmouth County for centuries, but Marlboro's noted dairy was founded by family members moving from northern New Jersey. The dairy's operation was complete from raising feed through the bottling process. Driving the tractor *c.* 1943 at left is M. Phillips Van Mater, while Pierre D. Van Mater Sr. is standing in the rear and Mack Clark, the Monmouth County agricultural agent, is in front. Pierre D. Van Mater Jr. is on the tractor at right. Both Pierres were known as "Duke" for their middle name, Du Clos.

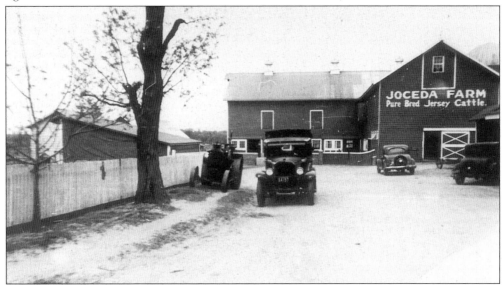

The Joceda name was coined from Joseph Appleton Van Mater, a geologist, after he dug a cedar tree in a field, replanted it in a yard, and the place became known as "Joe's Cedar farm." Pronounce "Joe's cedar" quickly three times. The dairy raised its own herd, taking pride in its high quality and the outstanding yield of carefully bred and raised cows. Mechanization and production techniques helped maintain a position as industry leader. Early barns are pictured *c.* 1930. All of them were destroyed in an October 1950 fire.

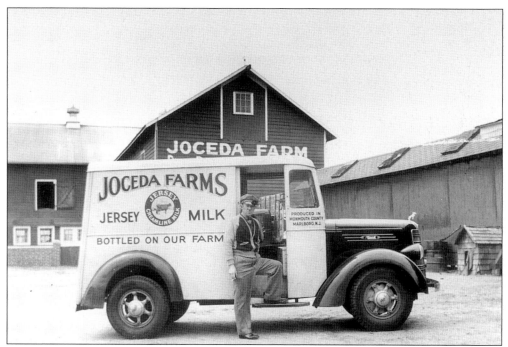

Retail delivery began around 1930, initially from "woody" station wagons. This truck, pictured with Ray Stearns from Holmdel, is legendary in Joceda annals. A 1940 Mack chassis was fitted with a used bakery body and run for 360,000 miles. Most Joceda vehicles were custom-built Internationals.

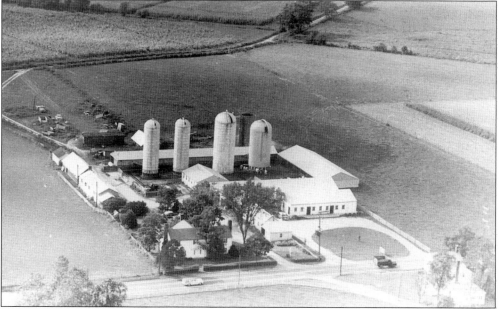

This c. 1950s aerial looks west across Highway 79, showing some of the 350 contiguous acres that the Van Maters assembled and the rebuilt dairy. The farm, sold in the early 1960s, is the site for most of the Monmouth Heights development. The dairy was merged into Welsh Farms in the mid-1970s and continued in production into the 1980s.

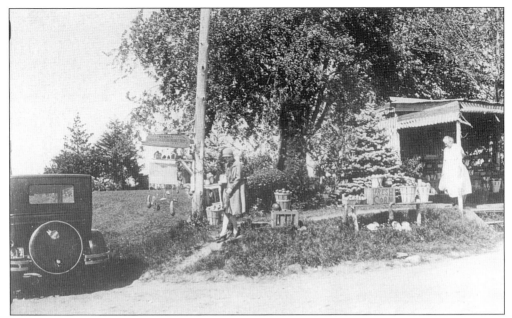

Brookrest Farm was begun by Jacob Stattel *c.* 1907 with his purchase on the east side of Highway 79. Louise Walter Stattel is pictured at right in the late 1920s at their road stand. Notice the appealing corn sign. Brookrest now includes a sod growing operation on the west side of the highway.

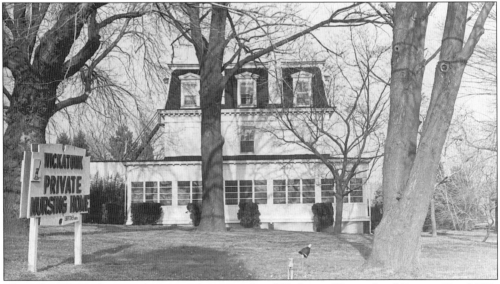

The John W. Herbert residence on the east side of Highway 79, north of County Road 520, gives an immediate impression of a commodious *c.* 1870s Second Empire house, the type one would expect for one of the period's most prosperous farmers, its obscuring by its nursing home porch notwithstanding. The house's beginnings are truly obscure unless one explores the rear to find its late-18th-century origins, a one-and-a-half-story structure with exposed hand-hewn beams and a walk-in fireplace, a section which was given a Mansard roof to match the main block. The building, which was first a nursing home in the 1950s, has a one-story extension on the north.

Terry Nespoli shows one way to go down in history—pose in front of an unusual place that photographic preservation nearly missed. The Hipsher mink farm is the background of this 1957 photograph; it was located on the future site of St. Gabriel's on the east side of Highway 79, south of County Road 520.

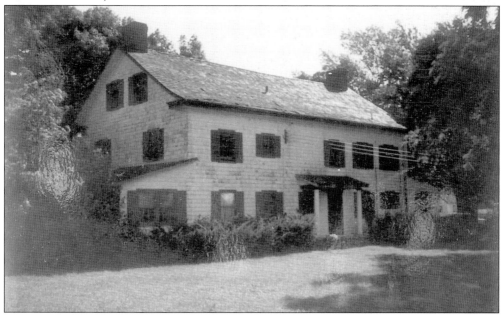

The building of the Coltsbrook development surrounded this 18th-century farmhouse with new construction. It appears built in at least two major sections and reportedly contains a 30-foot living room with two fireplaces. Once facing on Topanemus Road, the house, seen on the north facade now facing away from the street, is number 6 on a new street, Julian Way.

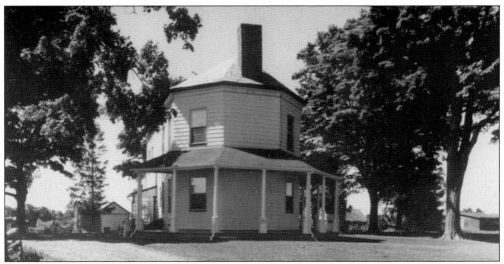

The origin of the house at the southeast corner of County Road 520 and Caldor Court has been estimated as late 18th century (Historic American Buildings Survey) and was reportedly an inn. Its name, Federal Hall, has been documented to c. 1820 and reflects architectural elements, albeit likely unintentionally. The solidly built place has cedar beams and brick-lined walls, some of double thickness. The doors are on the east and west facades. The north elevation, which faces the road, has been so often likened to resembling a steamboat that this repetition cannot do much harm, but the author offers the surmise that the shape may reflect a 19th-century alteration that attempted to increase available light on both sides.

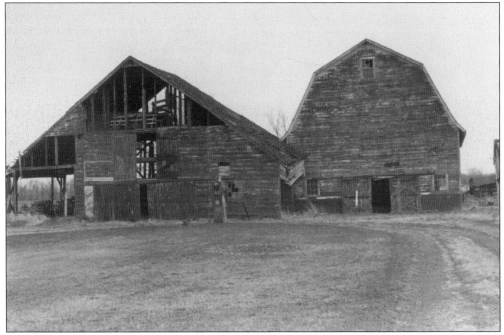

Federal Hall was the seat of a substantial farm (173 acres in 1933), owned by the Ely family for perhaps a century. Its outbuildings, which included an icehouse and smokehouse, survived into the 1980s. The barns were deteriorating when photographed in 1980 and were demolished in that decade as the farm was developed for the houses that now surround the old place.

Gilbert Van Mater Magee (right) bought the Ely farm in 1933 when it consisted of 123- and 49-acre tracts. He farmed the place and was succeeded by his son Garret, who retired from farming in 1968 and died in 1991. Garret married Sadie Robinson (pictured as a youth with her dog Buster), who survived until 1997.

The large Buck farm was east and north of Marlboro village, reached via Bucks Lane or a drive from Vanderburg Road. The house was destroyed, but 1940s glimpses during renovation illustrate early construction, such as the stone footing at right and foundation at left. Note the brick walls on the lower section, presumably the older. The two-and-a-half-story house had a later section, as the other side (not shown), had a brick foundation. The deteriorating round-butt shingles, seen at right, show their lathing as well as the brick walls underneath.

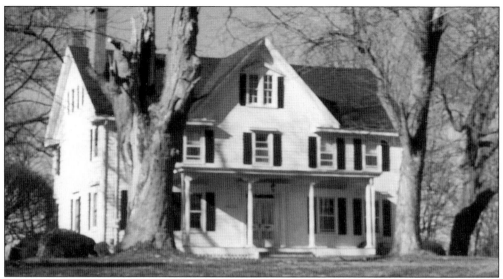

Tunis and Cornelius Vanderveer bought in 1722 a 350-acre tract from Stephen Warne in the southwest corner of the future Marlboro Township. This seat of the farm, the house at 176 Ryan Road, is associated with Tunis's son David R., who acquired 260 of those acres following his father's 1773 death. The oldest section likely dates from an unspecified part of the 18th century. There are later expansions, with the center gable an apparent 19th-century change. The house was rescued in the recent past from the development that now surrounds it.

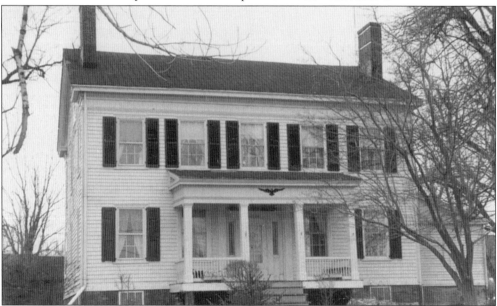

This fine, well-preserved Greek Revival house at 143 Ryan Road was built by David I. Vanderveer at an unspecified date in the mid-19th century. The property is part of the same early tract described at top. It is representative of a substantial house of the period, of a type that would have been built by a prosperous farmer, and it is important for surviving virtually unchanged. Since this photograph was taken in 1981, a garage was added on the west in place of the old kitchen at right, and new housing was built on the surrounding property. (Monmouth County Park System-Historic Sites Inventory.)

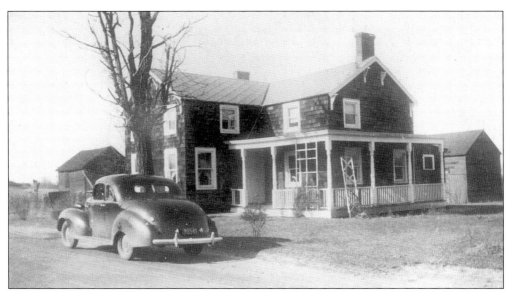

The traditional-style house at 6 Tennent Road, perhaps built c. 1890s, is pictured in the late 1930s. Then it was still part of a farm in an area changed in recent decades with some commercial development.

William Carter Ronson, born 1874 in Pittsfield, Massachusetts, after early agricultural efforts outside Monmouth County, bought a large farm, which has a surviving house at 67 Nolan Road. Photographed in 1946, its extensive acreage has been reduced, but the house is little changed. The barns have been replaced with a smaller, utilitarian structure.

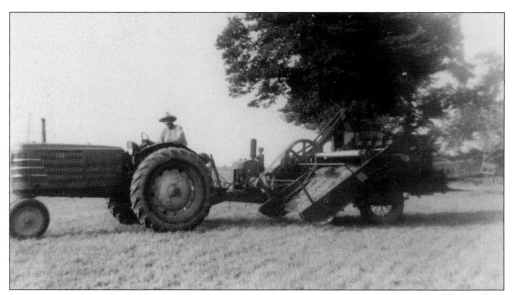

Straw is seen being baled by farm worker Bill Hankinson in June 1942. Ronson sold the place around 1943 and bought the Gordon farm in Pleasant Valley, pictured on page 14. Straw is typically baled, while hay is harvested and stored loose.

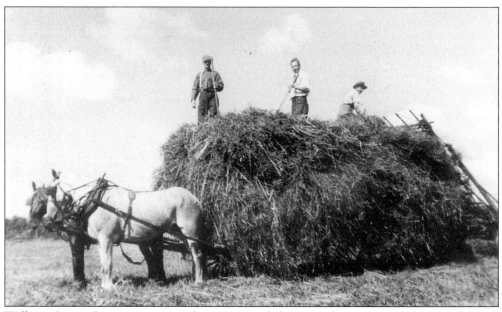

William Carter Ronson is pictured in 1940 at left atop a hay wagon. He married Sarah Holmes in 1896; they had one son, Clyde Vreeland Ronson, seen at right, next to farm worker Tom Keeler.

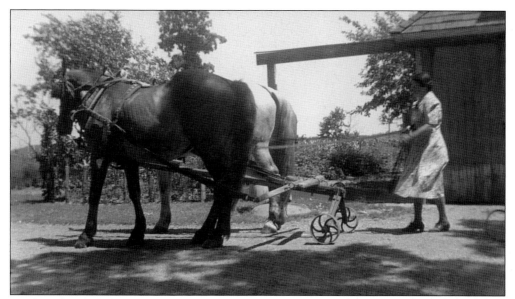

Sarah Holmes Ronson is pictured in July 1940 with horses Jerry and Frank, bringing in hay. She is using a haylift, a horse-pulled device, which by a series of pulleys, enables a hay fork with a trip rope to lift a quantity of hay from a wagon and deposit it in place on the upper floor of a barn.

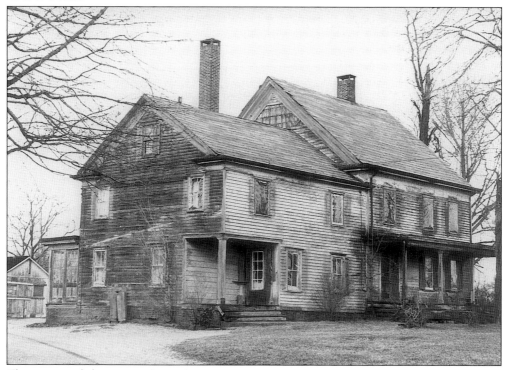

The H. Smock house was located on the short stem of Dutch Lane in Marlboro Township, near the Freehold Township border. The house, appearing to have seen better days than when photographed in an unpainted condition, was likely built in two sections, the older at right. Researching destroyed houses has its frustrations; this one burned in January 1979.

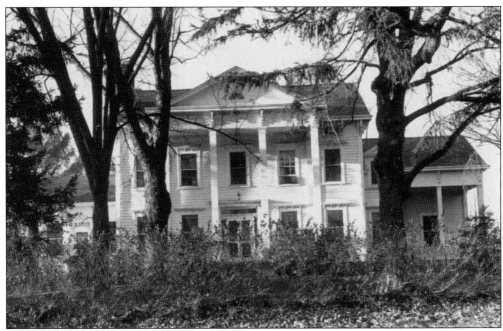

The two-story Colonial Revival portico obscures the *c.* 1860s origins of the five bay Italianate house at 164 Newman Springs Road. Located just west of the grounds of the Marlboro Psychiatric Hospital, the place was likely the seat of one of the many farms purchased by the State of New Jersey and for years was the residence of the hospital's director. (Monmouth County Parks System-Historic Sites Inventory.)

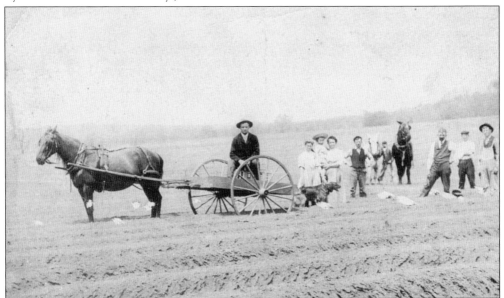

Harry Morris's asparagus field is seen *c.* 1910, located around Highway 79 and Lloyd Road, the site of the Marlboro Gardens development. Asparagus is a perennial, so cutting the same plant each year should appeal to the farmer. However, harvesting was back-breaking work. The crop suffered in times of labor shortage and fields were readily abandoned when the land became more valuable for other purposes.

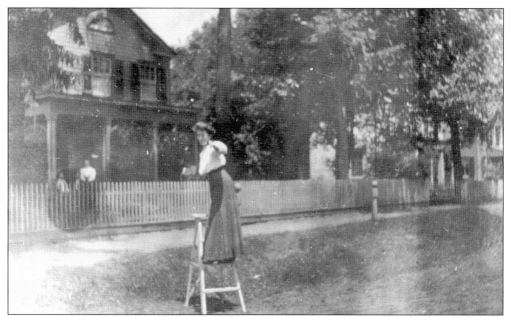

Clowning around on a step ladder *c.* 1910 in front of 9 North Main Street offers a good, vintage view of the Addison W. Hobart house. It may date *c.* 1840s, but appears to have its origins obscured by expansion. Addison was a local merchant and former school teacher, but the place's stature stems from his son, Garret A. Although raised here, the younger Hobart's political career was launched from Passaic County. Elected as William McKinley's vice-president in 1896, Hobart could have been president if he did not die in 1899, one year prior to McKinley's re-election and two years before his assassination. The vacant house is readily recognizable, but is missing its porch and is boarded up.

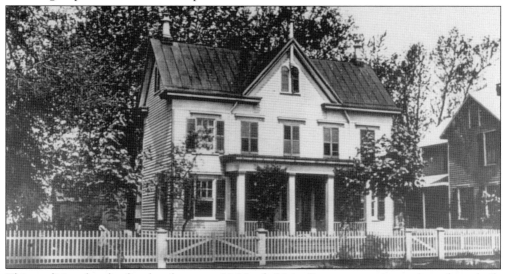

This traditional style, five bay house at 11 North Main Street, appearing to have been built *c.* 1860, has changed little, although the front gable may be a later addition. Henry Magee, a Marlboro tax collector, was a former owner, using the place as his office while holding that position. The house has been sided in vinyl and has a new porch. A partial view of number 13 is at right.

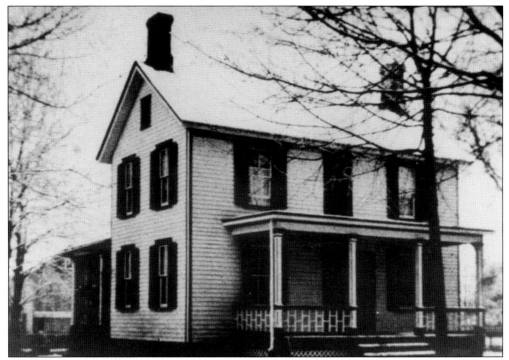

Number 15 North Main Street was photographed *c.* 1910 as the home of Frank T. Burke. The *c.* 1840s traditional-style building housed the Tally Ho Tearoom in the 1930s. A second look may be required now to recognize the old house, remodeled as offices, its character changed by shingling and removal of the porch and chimneys.

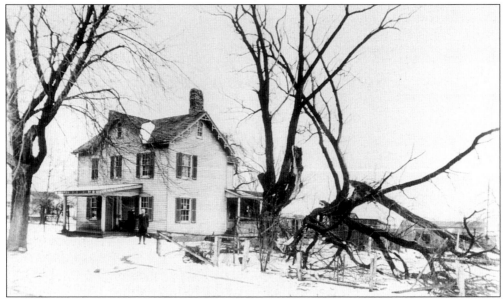

This traditional-style house at 26 Hudson Street dates *c.* 1860s and stands little-changed, although missing its vergeboard and possessing a later, narrow porch. The fallen tree, on a lot now separated from the house property, seems to be the occasion of the photograph, dated by the World War I-era Red Cross label on the window. It was owned then by William C. Herbert.

Jane (or Jennie) Shemo Minkerson Taylor is pictured with her son James Henry Minkerson *c.* 1890. She was reportedly a former slave owned by Hendrick Smock. Minkerson (also pictured on page 97) is associated with more than one property in Marlboro. This house is believed to have once stood on School Road East. (Collection Monmouth County Historical Association.)

This substantial vernacular Victorian house, with a steep, prominent center gable, at 12 Hudson Street was built *c.* 1870s, perhaps by the Morses, who bought the lot in 1876. The place, standing hardly changed (except for the rear entrance at right), has long been owned by the Burke family; Mary Ann is pictured in the foreground of this *c.* 1895 photograph.

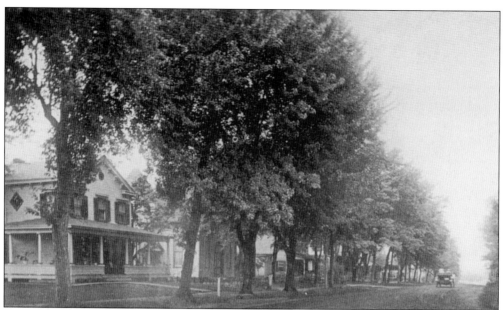

Main Street looking north from Vanderburg Road had the ambiance of a town street when published on this *c.* 1910 postcard. It has the character of a highway now, but the two pictured buildings stand, albeit with changed occupancies. The porch on the house at left, number 19, was enclosed; the building recently housed a gallery. Adjacent is the Reformed Chapel, seen clearly on page 77, now a dance studio. (Collection of Harold Solomon.)

The Colonial Revival is visible as one proceeds away from Main Street's older origins, such as in number 29 at right, a *c.* 1920s addition to the streetscape. It is unchanged with the exception of the removal of its center second-story window. Lester Cook is seen in 1966 on the lawn of number 27, a *c.* 1890s house, unchanged other than its wrought iron porch balusters.

Two

COLLIER

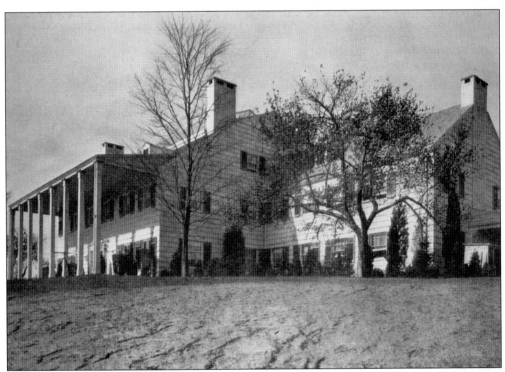

The Collier estate is arguably Marlboro's most historically significant property. A rare example of a Monmouth County country house set away from its rivers or ocean shore, the vast tract of former rich farmland is a landmark of early aviation history. It is now home to an outstanding spiritual-educational organization, The Sisters of the Good Shepherd, who conduct Collier Services. The house, built during the high point of the Colonial Revival, was designed by John Russell Pope with one of that period's architectural icons, the Mount Vernon porch. Facing south on a high hill, it is seen on that facade in a picture published in *The Architectural Record*, July 1912.

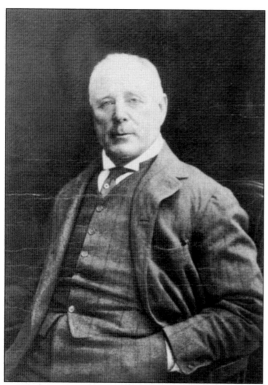

Peter Fenelon Collier, born at Myshall, County Carlow, Ireland, in 1849, immigrated to America at age 17, worked briefly in Ohio, and studied in a seminary for six months prior to becoming a salesman for a book publisher. He entered the publishing business, achieving enormous success with *Father Burke's Lectures*, which inspired him to publish other Catholic books. Collier's earlier works included *Collier's Library*, a subscription series of popular literature, and *Once a Week*, the forerunner of *Collier's Weekly*. His astute business practices earned great sums for Collier and his firm P.F. Collier & Son Company. Collier married Katherine Louise Dunn. Collier died in 1909.

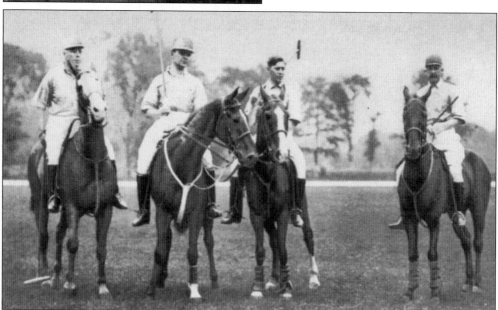

Peter F. Collier was active in a number of clubs and sporting organizations in Monmouth County and on Long Island. He had a farm in Eatontown named "The Kennels, reflecting his interest in fox hunting, a pursuit he helped organize locally. Collier, at left, a fine polo player, is adjacent to his son Robert, together with R. La Montagne Jr. and W.H. Hazard, at right, on the Junior championship team of 1904 at the Rockaway Hunt Club." From *In Memorium Peter Fenelon Collier*, 1910.

Robert Joseph Collier, born 1876, graduated Georgetown in 1894, later studying at Oxford and Harvard, leaving the latter to join *Collier's Weekly* as a correspondent during the Spanish-American War. He assumed the editorship of the magazine and became head of the company upon his father's death in 1909, effecting a contentious, crusading reporting policy that attracted a number of libel suits. The younger Collier supported many historical and cultural organizations, starting the group that purchased Lincoln's "birthplace" in Kentucky. He was an avid outdoorsman, participating not only in equine sports, but became an enthusiastic aviator as well. (Collection Sisters of the Good Shepherd.)

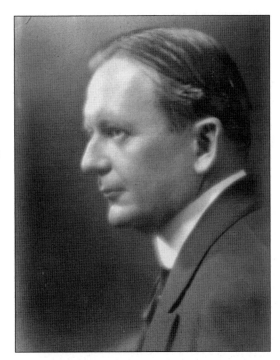

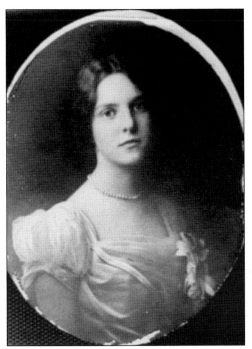

Robert J. Collier married Sarah Stewart, daughter of James J. Van Alen, at Newport, Rhode Island, in 1902. They had one child, who died shortly after birth. Sarah survived until 1963, but donated the Marlboro estate to the Sisters of the Good Shepherd in 1927, early in her widowhood. She maintained a life-long interest in the Sisters' work, leaving them her estate upon her death. (Collection Sisters of the Good Shepherd.)

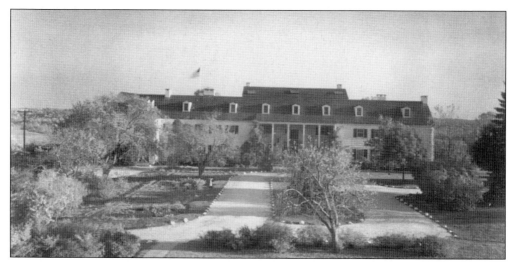

A country house is a large dwelling, usually artistically designed, built on an ample spread of land, located away from urban population centers, intended as a temporary home during the summer months. These houses were often built by wealthy country-born industrialists who wished to "return to the land," using their business wealth in gentlemen's farming. Collier assembled about 350 acres, some of them once owned by names well known locally, including Sickles, Honce, Conover, and Crine. The north elevation is seen through a small Collier orchard. (Collection Sisters of the Good Shepherd.)

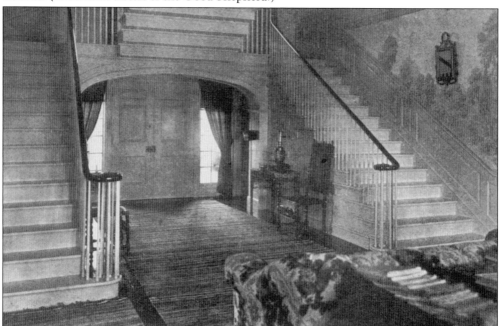

John Russell Pope, born in New York in 1874, studied architecture under Professor William Ware. He was among the first students at the American Academy in Rome and later studied at the Ecole des Beaux-Arts. Country houses dominated Pope's early career. Reflecting its rural surroundings, the Collier house, completed in 1911, was a simplified design from an architect whose country house work was more often characterized by larger, brick houses of Georgian influence. The center hall contains a double staircase. (*The Architectural Record*, July 1912.)

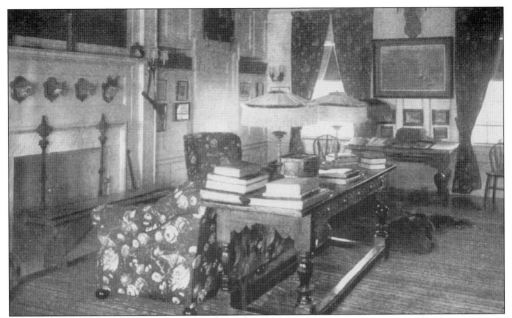

Pope was a classicist, having spent two years traveling in Italy, Greece, and Sicily in serious study of monuments. Although restrained in comparison with the architect's larger works, the Collier house is richly decorated in every room. This picture is Collier's library. He was a rare book collector, as well as a publisher. (*The Architectural Record*, July 1912.)

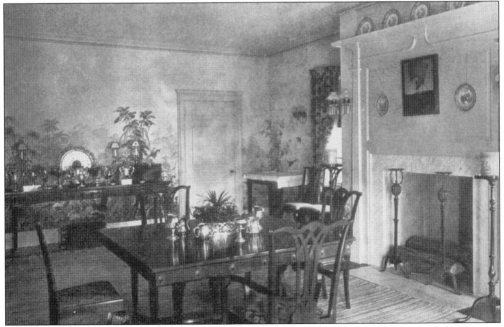

Peter Collier planned to build the Marlboro house, but died prior to execution of the project, with the record not having revealed if the work as built reflects the elder or younger Collier's desires. It is believed Peter had the forethought of securing a burial ground when he first purchased Marlboro property, the possible origin behind the estate's name of *Rest Hill*. This is the dining room. (*The Architectural Record*, July 1912.)

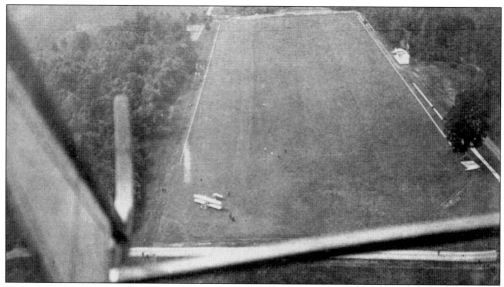

The grounds north of the house were laid out for polo; both Colliers were skilled, enthusiastic players. It was built by P.A. Hart of Philadelphia, a contractor and polo player; the job required the filling of slopes on the south and east sides. The long and flat field was also suitable for Robert's emerging interest in aviation, stimulated by Wilbur Wright's September 1909 flight from Governors Island in New York Harbor. Collier enrolled in the aviation class conducted by Frank Coffyn, a Wright associate, at Augusta, Georgia, in 1911, the same year he became the second in America and the first in the New York area to buy a Wright Model B bi-plane for private use.

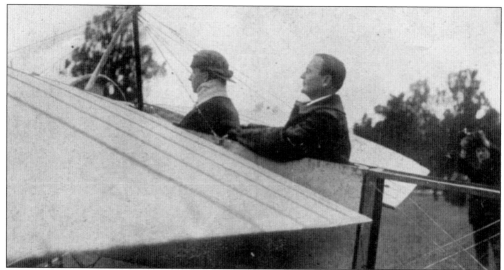

Robert Collier hosted a party on October 14, 1911, that for practical purposes was the introduction of aviation to Monmouth County. He is seated behind famed British aviator Thomas O.M. Sopwith, probably in the two-seater Gnome Bleriot, which Sopwith intended, but was reportedly unable, to fly that day. Sopwith, later knighted, became a legendary builder of aircraft, including the Sopwith Camel and Hurricane of World War I and II fame, respectively. Aviation co-existed with polo that day, the flying starting after Collier's Wickatunk team lost to visitors from Rumson. Brave locals were given their first airplane rides.

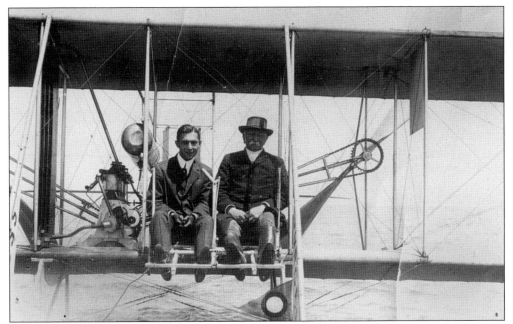

Collier's Wright bi-plane was lent to the federal government for service during the 1916 Mexican insurrection. Based in Texas, the plane was named *Laredo* on its return. Collier is seated at left, on the *Laredo*, with friend Herbert, a local farmer and property owner. (Collection Sisters of the Good Shepherd.)

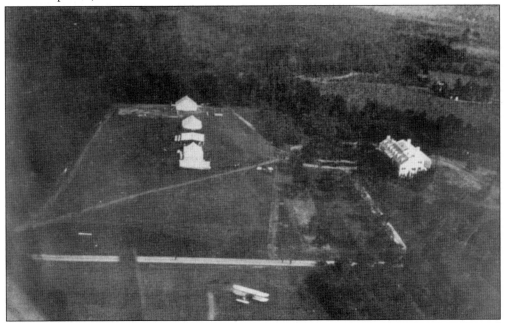

A 1911 news account indicated Collier paid a reported $5,000 for his airplane, a sale predicated on personal use only as flying for money or prizes would have required a $100 daily royalty. This view (which along with the two on the facing page were photographed at the October 14, 1911 event) shows the field in relationship to the house. Tents were erected for food service for a reported 2,000 guests.

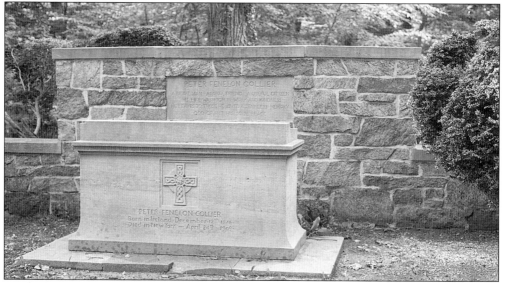

The Collier gravesite, on a hillside a short distance from the property's main paths, remains a spot of contemplation and beauty. It is believed the forethought of a final resting place prompted Collier to name the estate Rest Hill.

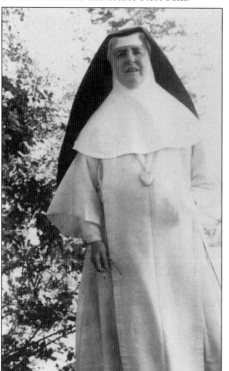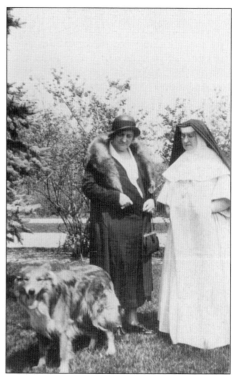

The Sisters of the Good Shepherd opened in 1875 at Newark, New Jersey, the first Good Shepherd program to serve girls and women. Sarah, Robert Collier's widow, gave the sisters her Marlboro home, enabling them to move to Rest Hill in 1927. Mother Mary Bernard is pictured at left in 1927 when named the first mother superior and again at right with Mary Smith, a benefactor long-interested in the Sisters' work. (Collection Sisters of the Good Shepherd.)

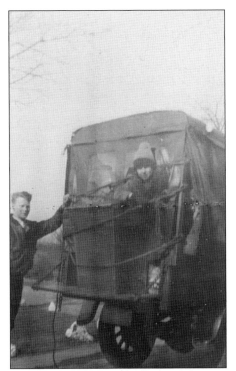

The first children are seen arriving on February 26, 1928. There were 32 girls enrolled by the end of that year and 110 five years later. Veronica Wright Barrett, seen leading the new arrivals, developed a long association with the Collier School. (Collection Sisters of the Good Shepherd.)

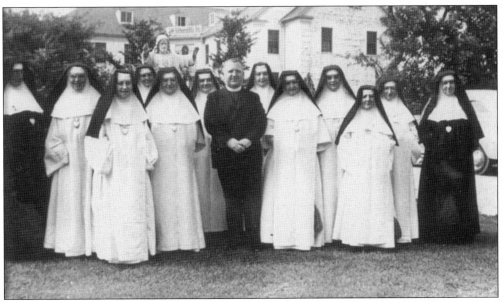

Father Sullivan was of longtime spiritual assistance to the sisters and girls Collier. He is pictured in the first row, together with Sister Victory, Mother Bernard, and Mother Divine Heart. (Collection Sisters of the Good Shepherd.)

The school was founded in the former Collier carriage house, a building located about halfway down the hill from the house. The building originally contained dormitory space for 16 workers, but students in the early days were housed in the main residence. The building, now the Kateri Environmental Center, founded in 1979 (and pictured in 1980), is the site for a variety of environmental programs and a summer day camp.

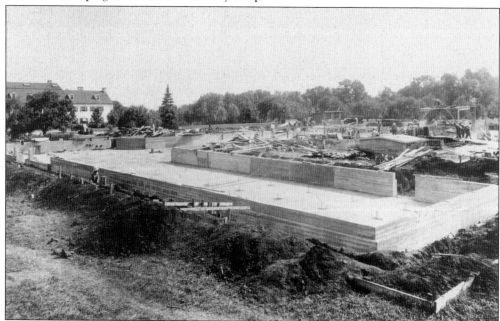

A large gift by Mary A. Smith, wife of John Thomas Smith of New York, permitted construction in 1937–8 of a large dormitory, built on the former polo-aviation field. The architect was Robert J. Reilly of New York, while Edward M. Waldron Jr. was the contractor. This construction scene dated August 2, 1937, is given site perspective by the Collier residence in the background. (Collection Sisters of the Good Shepherd.)

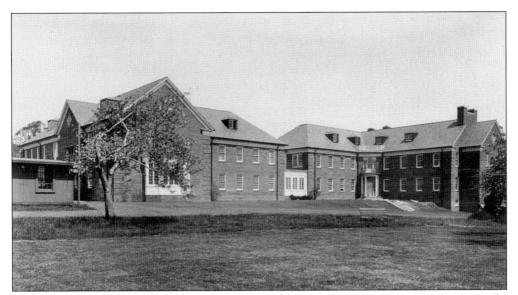

The new dormitory, pictured on May 2, 1938, was dedicated on June 23, 1938, by the Right Reverend Moses E. Kiley, fifth bishop of the Diocese of Trenton. The first floor contained several instructional rooms, health care facilities, and the food preparation-service operation. The red brick structure, painted white (sigh!) to match the Collier residence, was named Mary A. Smith Hall in honor of its benefactor. (Collection Sisters of the Good Shepherd.)

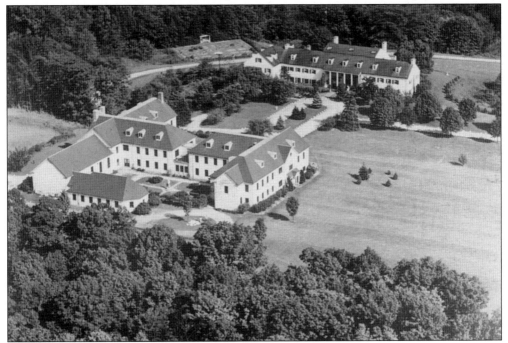

The Smith Hall dormitory for 125 girls facilitated the opening of a separate school in the Collier home; St. Dorothy's School (honoring Mrs. Collier through her confirmation name), began in 1939. The school was now able to provide a three-year academic and vocational high school diploma, in addition to an elementary diploma. Smith Hall was expanded and adapted to changing needs on a number of occasions. (Collection Sisters of the Good Shepherd.)

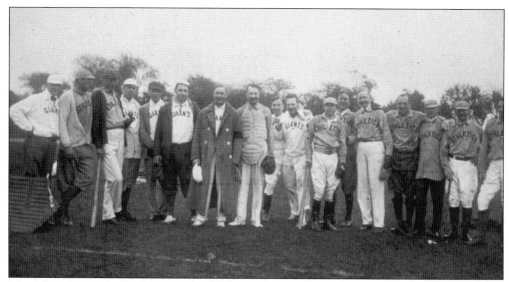

Members of the New York Giants and Philadelphia Athletics are seen at an unidentified event at Rest Hill *c.* 1912. You are getting old if you remember when the A's were in Philadelphia. Come to think of it, you are not so young if you remember the Giants in New York. They moved from those cities after the 1953 and 1957 seasons respectively. (Collection Sisters of the Good Shepherd.)

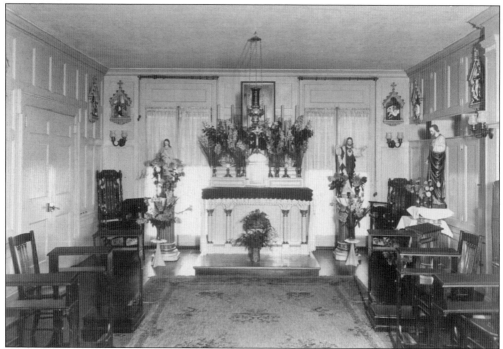

Sarah Collier converted to Roman Catholicism prior to marrying Robert, becoming a devout practitioner. She received permission to install a private chapel in her residence and was long-interested in the Sisters' work. Sarah died in 1963; her major bequest permitted construction of a new Collier High School, dedicated in 1968. The undated image of the chapel dates from the Sisters' occupancy. (Collection Sisters of the Good Shepherd.)

An estate pump house provided the foundation for an environmental observation building, erected by young workers in 1979–80 under a Comprehensive Employment and Training Act program. The blocks at left suggest the project was not yet completed when photographed in September 1980. The building is now used for special events.

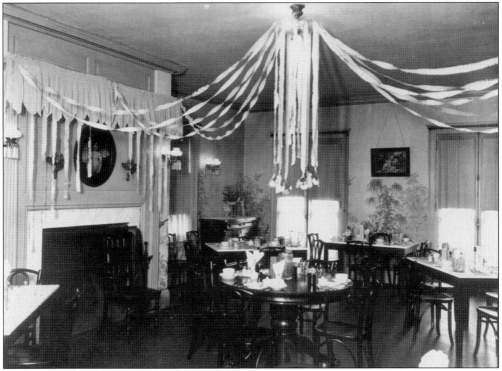

The former Collier library, now a dining room, is seen in an undated photograph decorated for a special event. The residence has by necessity of its occupancy been expanded, while rooms were adapted for new use. However, the interior is maintained with a good degree of integrity. (Collection Sisters of the Good Shepherd.)

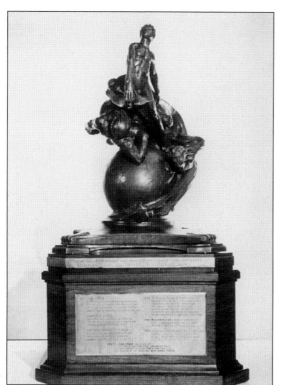

Robert J. Collier became president of the Aero Club of America in 1911, the year he donated this 525-pound trophy, mounting Ernest Wise Keyser's sculpture symbolizing man's triumph over gravity, which was to be awarded in the club's name. He sought to promote the positive aspects of aviation and to discourage reckless flying. After his death, the trophy was renamed for Collier by the National Aeronautic Association, successor to the Aero Club. The trophy, on permanent display at the National Air and Space Museum, Washington, has become the field's most prestigious award. The Collier trophy's recipients read as a "who's who of aviation." (Collection Sisters of the Good Shepherd.)

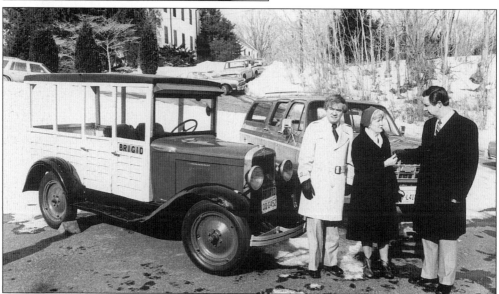

Sr. Dorothy Ryan found this 1929 Chevrolet in a barn in Peekskill, New York, in 1951, and she used it for utilitarian transportation, naming the vehicle *Brigid* for her great-grandmother. Realizing its historic interest and needing a new vehicle, she lent it in 1977 to General Motors for exhibition purposes in exchange for ownership of a new Suburban. Sr. Dorothy retained *Brigid* for many years, selling it in 1997 to a New Jersey collector who is giving the car restorative care. She is pictured that January with automotive representatives at the time of the 1977 exchange.

64

Three

SCHOOLS

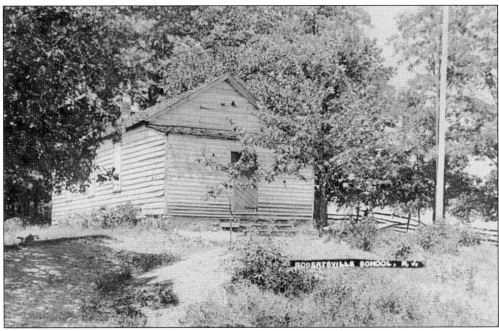

The Robertsville school was built on the northwest corner of Tennent and Union Hill Roads. This 19th-century structure, given an 1832 date in Ellis's *History of Monmouth County*, is seen on a Merriman photographic postcard postmarked in 1910. The school was replaced in 1912 by the building now on the site, one remodeled for special educational use and now apparently an office. (Collection of Harold Solomon.)

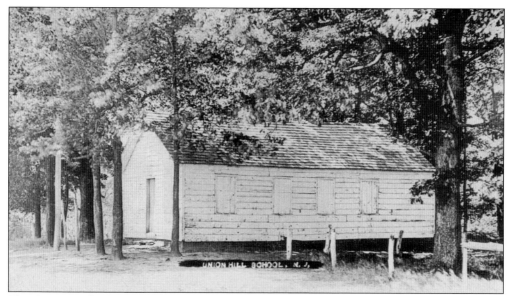

This Union Hill school, according to Ellis, was an 1871 reconstruction of a *c.* 1823 building which stood on Union Hill Road and the road that was later made part of Highway 9. It is believed this structure was replaced *c.* 1915, on a lot on the opposite side of the highway. The later school closed *c.* 1930; the long-vacant building disappeared within the last generation. The Merriman photographic postcard was issued *c.* 1910.

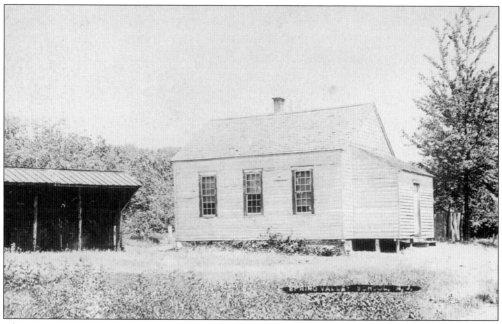

This Spring Valley school, located on the north side of Spring Valley Road, near Texas Road, was an 1910 replacement of an 1850s building. It was condemned as unsafe in 1919 and replaced by a new school on the west side of Tennent Road. The structure, pictured on a *c.* 1910 Merriman postcard, still stands in derelict condition, clad in deteriorating wood shingles, after apparent conversion to a residence. The district was alternately known as Strongs Number 44.

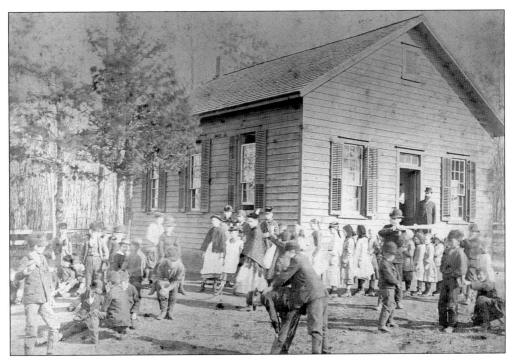

An 1880 candid school activity picture is rare and helps belie the contention that early group portraits, including school classes, are unsmiling because slow film demanded stiff poses. One presumes the occasion at the Morganville school, at the northeast corner of Highway 79 and Harnley Road, was an unidentified special event as the children appear too well dressed for a school day. (Collection of St. Gabriel's Church.)

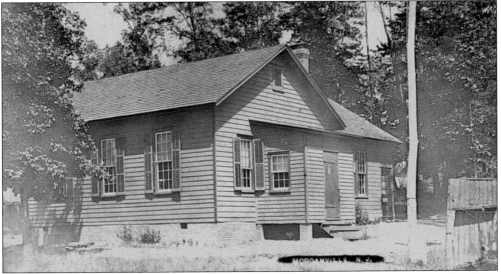

The Morganville school, built in 1873, had an ell and vestibule added by 1910. This school was replaced in 1915 and moved to the west side of the highway, where it was remodeled into the firehouse of the Morganville Independent Fire Company. It was moved again in the early 1950s when the fire company relocated to its present site. The school's original appearance has been lost to additions and alterations.

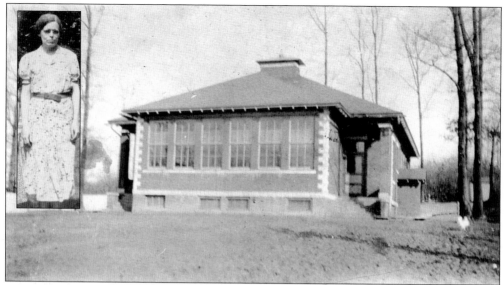

A new Morganville school was built in 1915, designed by Warren H. Conover of Freehold. It is believed this perspective is from the northwest corner, but the original three-room structure has been enveloped by several additions. The Marlboro system last used the building in the mid-1970s; it is now occupied by the Coastal Learning Center. Mary Crine taught the seventh and eighth grades early in her career, later serving many years as principal.

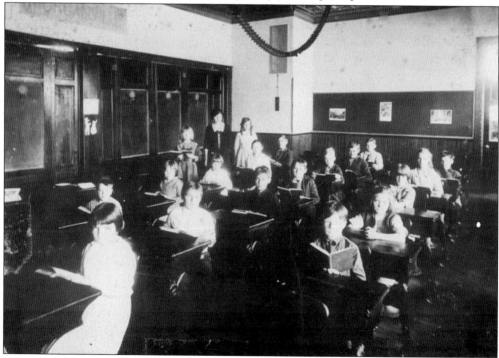

The handmade sign at upper left saved this image, perhaps dating from the 1920s, from the anonymity plaguing so many school pictures. It is possible the adult in the back of the room is Mary Crine. Note the pressed tin ceiling, the fine woodwork, and the two girls who presumably forgot their books.

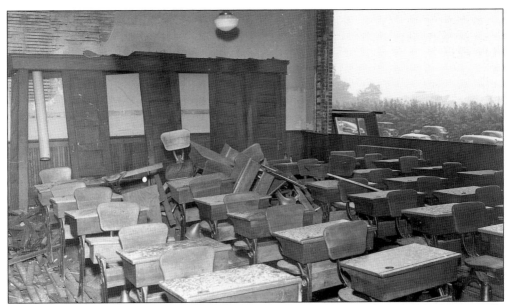

A gas explosion set off by a spark from a light switch wrecked the north end of the Morganville School on August 1, 1950. William Sickles, the janitor who threw the switch, was burned on his arms and body. A fire was quickly controlled and the school was repaired for use that fall. (The Dorn's Collection.)

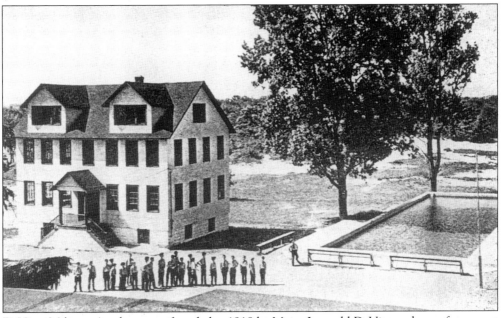

DeVitte Military Academy was founded c. 1918 by Major Leopold DeVitte, a law enforcement veteran with a self-designated officership, and his wife Suzanne. It was co-educational in the early years, adapting the all-male military theme by the late 1920s. They erected five school buildings and a series of cottages on Woolleytown Road. The out-of-town student body of about 80 boys attended through grade eight. Dora Devitte Sweeney and her husband Walter operated the school after World War II until it closed in 1978. A single building at number 31 survives, adapted for the Hindu-American Temple and Cultural Center.

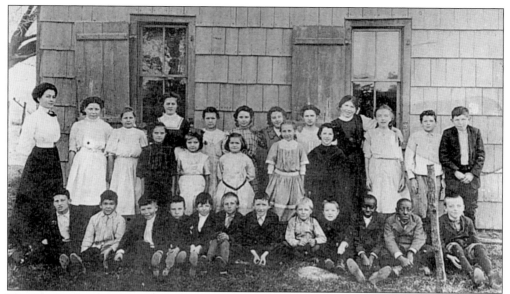

The Bradevelt school originated *c.* 1810 in an old house, a building replaced *c.* 1825 by this building on the north side of County Road 520, near the Reformed Church. This photograph from 1909 shows Miss Hettie Cook's class. The students reflect an unusually wide range of emotions from the sullen, to the content, to the puzzled, and the interested. Mabel Stattel Preston, fourth from the left in the middle, is the sole survivor. Frank Dugan, seventh from the left in the row of seated boys, became a Marlboro educator of note; a school is named for him. Former Vice President Garrett A. Hobart and his father Addison were reported to have taught simultaneously at this old building, which, too, was replaced *c.* 1914.

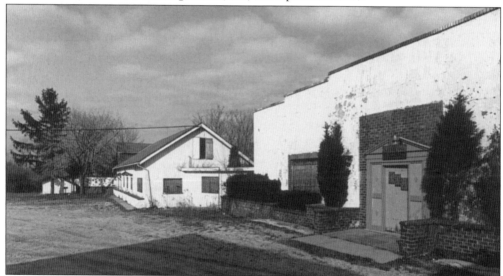

The former Doyle apple orchards became the site of schools for the emotionally handicapped, but its early instructional history is obscure. It appears the Hilltop and Hillview Academies were begun in 1965 and 1967 respectively. A Grandview Academy also existed and was closed when photographed in December 1977. CPC Behavioral Healthcare now operates the High Point Elementary School and High Point Adolescent School on the site. The building at right was replaced by a modern brick school in 1991.

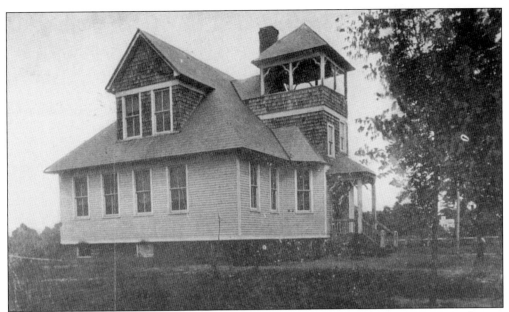

Marlboro's new elementary school on the north side of School Road West, was, according to its building contract, a two-story structure erected by William H. Soden of Freehold. The too-large dormers and the ill-fitting tower perhaps comprised a second story in what appears to be a one-and-a-half-story building; its dismal aesthetics are surprising as the architect was the skilled Warren H. Conover. The school served through 1923 and was replaced at the end of the year by the school pictured below. (Collection of Harold Solomon.)

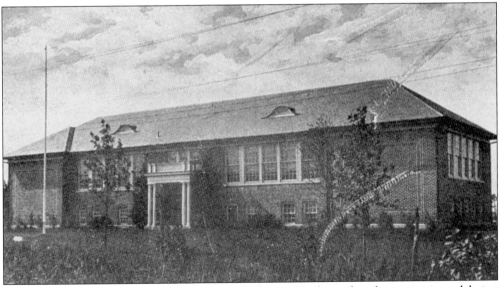

The Marlboro School at 22 School Road East, built in 1923, shows the advance in size and design of elementary school buildings over a one decade period when compared to the Morganville school on the top of page 68. This one, of handsome Colonial Revival design, was made up of four rooms and served into the 1970s. An expansion about the size of the original building has been affixed to the southwest corner of the building (at far right) by its present occupant, the Solomon Schecter Day School. (Collection of Harold Solomon.)

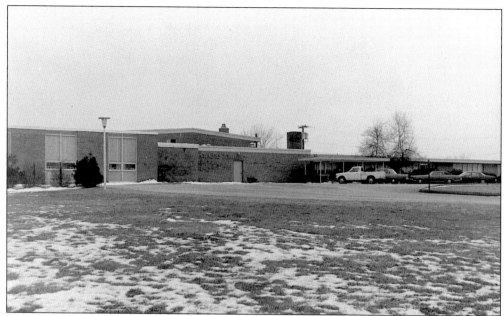

The Marlboro Central School was built in 1956 on Highway 79, designed by John MacWilliam. The name suggests its locale, south of Morganville, north of Marlboro village and near the township's principal east-west road, County Highway 520. MacWilliam was also the architect for two additions, in 1963 and 1969. The school is pictured in 1979. In 1992, Central was renamed DeFino School in honor of Frank DeFino, who served Marlboro as assistant superintendent of schools from 1971 to 1976 and as superintendent from 1976 to 1992.

The three-story Marlboro Middle School was completed in 1976, built on a 47-acre tract on County Road 520, west of Wyncrest Road. Architect Jules Gregory planned the 146,000-square-foot building in three wings designed to be independent of one another. The school, which opened that September, is pictured at its December dedication.

Asher Holmes Elementary School, built in 1974 on Union Hill Road, near Tennent Road, was named following the recommendation of students who researched the Revolutionary War patriot. This c. 1975 view appears to be the north facade, which has been altered by an addition placed in front of it.

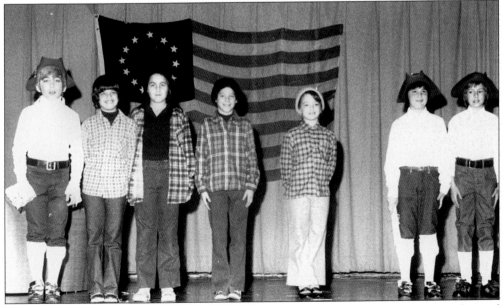

The Asher Holmes Elementary School dedication program on January 5, 1975, featured a historical tableaux narrated by Lotta Burke, with seven students taking the rolls of Asher Holmes' children. They are, from left to right, Larry Karp, Cheryl Schuler, Lisa Landau, Ann LaMura, Janet Janssen, Neal Gulkis, and Neal Masello. The school's fife and drum corps also played.

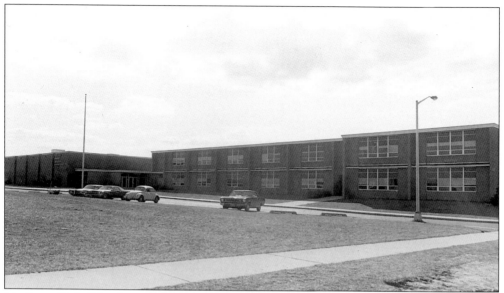

Marlboro High School, pictured in 1975 and located on the west side of Highway 79, south of County Road 520, and part of the Freehold Regional High School District, opened in 1968. Marlboro students earlier went to Freehold or Matawan for their high school studies. Following a spell of staggered sessions, the school was expanded around the 1980s.

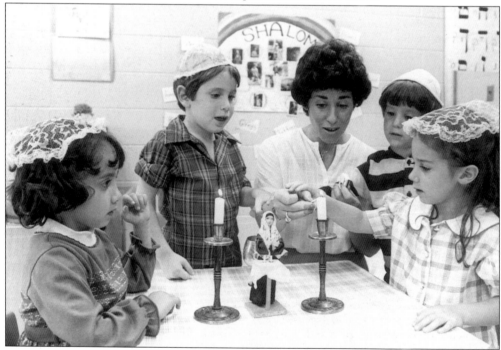

Marlboro's Solomon Schechter School, an affiliate of a New York headquartered organization overseeing a national network of schools instructing in the Jewish tradition, had its origins in 1979 at the Congregation Ohev Shalom building on School Road West. Judy Ferber is seen that year teaching the custom of lighting Sabbath candles to, from left to right: Taly Halitsky, Jeffery Lovman, Bryan Silverstone, and Marni Fruchtman.

Four

HOUSES OF WORSHIP

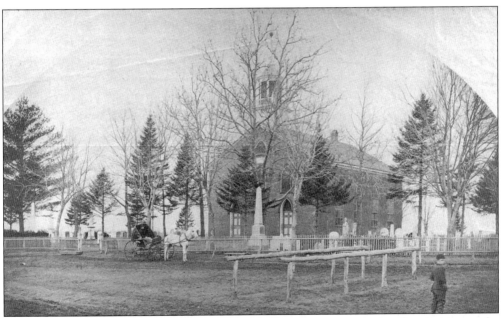

The present edifice of the Old Brick Reformed Church, a congregation first known as the Reformed Church of Navesink and later as the Dutch Reformed Church of Freehold and Middletown, at 490 County Road 520, was built in 1826. It replaced a church built on the site in 1732. Old Brick's facility includes an education building, Volharden Hall, built in 1970. The earliest internments in the cemetery are from the 1740s. The photograph, perhaps late 19th century, was taken from the south side of a road level with the street prior to its depression following removal of the bridge crossing the adjoining railroad. (Special Collections & Archives, Rutgers University Libraries.)

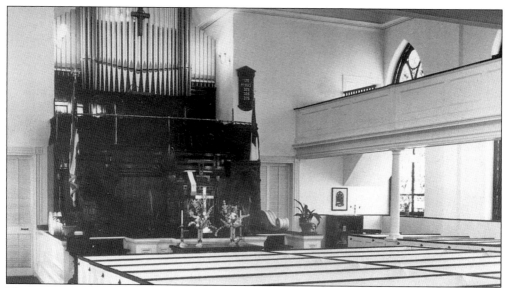

This interior was given noticeable modifications for the tercentenary celebration. A semi-circular loft (not discernible due to a lack of contrast) was removed from in front of the organ, and the pulpit was raised. The 1890 Reuben Midmer tracker organ was replaced in 1995 by another pipe organ from Schantz. Its pipes were erected away from the center of the facade, some in storage areas built in the rooms adjacent to the balcony pews (occupied by slaves in early years), making a stained-glass window visible from the interior for the first time since its 1905 installation.

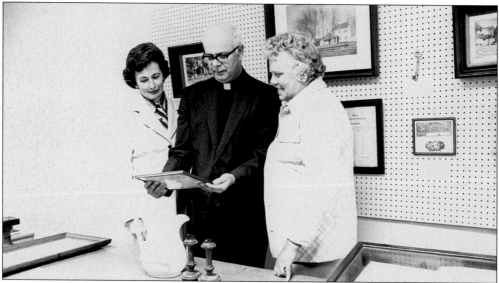

Celebrating history is important to Old Brick. Seen preparing for the 275th anniversary in 1974 are, from left, Elizabeth Van Mater, music director, the Reverend John Hart, and Claire K. Hayes. The church, claiming origins from the 1699 commencement of preaching by visiting clergy from Brooklyn, New York, was formally organized in 1709, sharing a minister with a Presbyterian congregation in its earliest years. The site of their first house of worship, believed to be in the village, has not yet been found. The 1999 tercentenary was marked by numerous events and publication of a new history, the latest of a series of church publications.

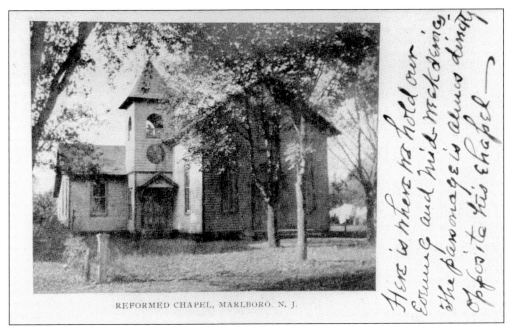

REFORMED CHAPEL, MARLBORO, N. J.

The writer of this *c.* 1905 postcard described the use of the Reformed Church's in-town chapel, a building even more extensively used in winter, as the main church was difficult to heat. The chapel, at 21 North Main Street, completed in 1869 with later additions, was sold to the Monmouth Christian Church in 1969. It is now a dance studio and retains a high degree of integrity after adaptive use. (Collection of John Rhody.)

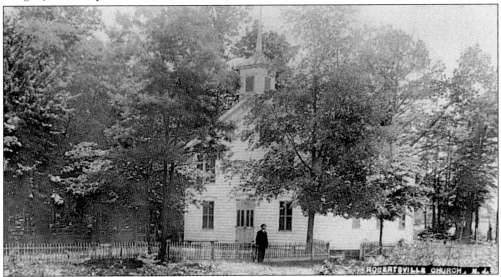

The Robertsville Church, founded in 1883, acquired this building formerly used for worship by Methodists in Englishtown, and later as a music hall, and moved it along Tennent Road to its present location at the southeast corner of Church Road. Initially a Methodist congregation, too, Robertsville broke away in 1939 and has been known since as the Robertsville Bible church. The church, possessing fine stained-glass windows, is little changed, but worship is conducted in a nearby annex as the main building awaits structural reinforcement. (Collection of Harold Solomon.)

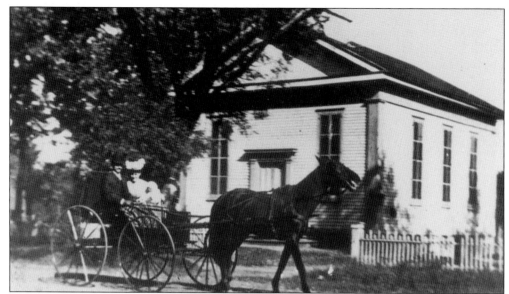

The First Baptist Church of Marlboro was organized in the 1860s, building this fine Greek Revival edifice at the southeast corner of Main Street and Vanderburg Road in 1866–67 on a lot purchased from Obadiah C. Herbert. The church disbanded in 1939, in time selling this building to Liberty Grange Number 99, which occupied it as a hall. The church is pictured c. 1910; the subjects are unknown.

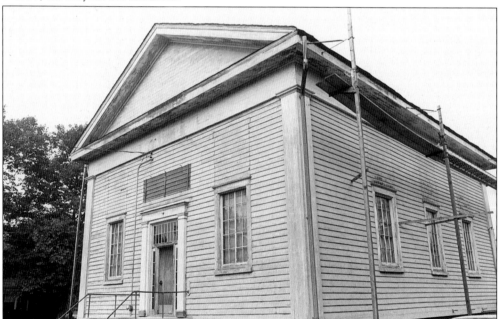

The Baptist Church-Grange Hall has undergone two renovations in the past quarter century. Work underway visible on this 1975 picture clearly depicts the old structure. Since then a second story has been built internally (in lieu of a balcony), resulting in reconfiguration of the side windows, which now look more like the originals, while the front windows were removed and a new, wide door built. A stuccoed cornice was added and a ventilation opening cut in the pediment. Only the basic shape of the old building remains; at least it stands.

This *c.* 1910 photograph of the Baptist parsonage at 20 North Main Street shows the church tower (since removed), which is obscured on the facing picture. This traditional house, with an appealing bay window, completed in 1907, is now in use as a private residence, little changed except for the addition of vinyl siding.

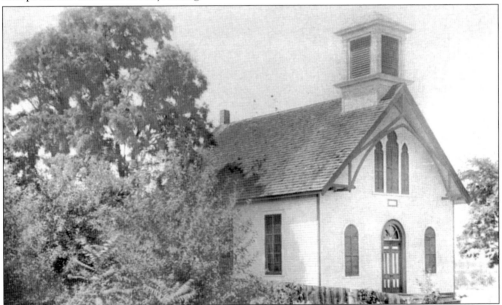

The Morganville Methodist Church was founded in 1869, following early Methodist worship there in the late 1860s. Their edifice, of Victorian Gothic influence, built soon after the 1869 purchase of a lot on the southwest corner of Highway 79 and Church Lane, was named the Bishop Janes Chapel in honor of Bishop Edmund Storer Janes. The building, remaining in use until the congregation's 1981 relocation to Conover Road, has lost most church elements in its remodeling to offices, but remains recognizable, especially if one has this *c.* 1910 Alick Merriman picture. (Collection of Harold Solomon.)

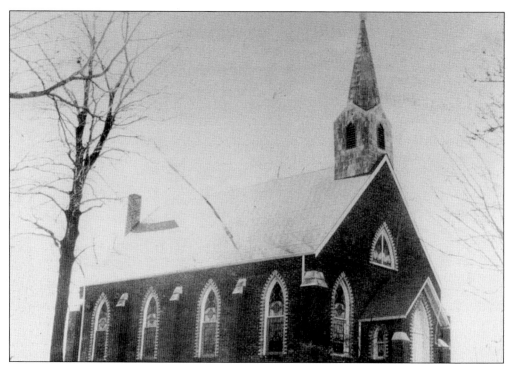

Catholic worship in Marlboro began by c. 1870, with visiting priests celebrating Mass either in the woods during summer, or in the homes of John Carthy and Patrick Brophy. The Very Reverend Frederick Kivelitz of St. Rose of Lima in Freehold became the regular Marlboro visitor in 1871, building this 30-by-50-foot brick Victorian Gothic church on land donated by Patrick Fallon. Bishop Michael A. Corrigan was present for the cornerstone ceremony on July 14, 1878, and the dedication on November 3, 1878. (Collection St. Gabriel's Church.)

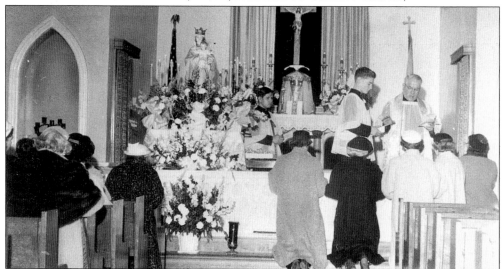

The church became a separate parish in 1885, building a rectory next to the church that year for the Reverend John O'Leary, their first pastor. The interior is pictured as the Reverend Vincent A. Lloyd, pastor from 1960–66, is celebrating Mass, believed to be part of an installation of members or officials in a church organization.

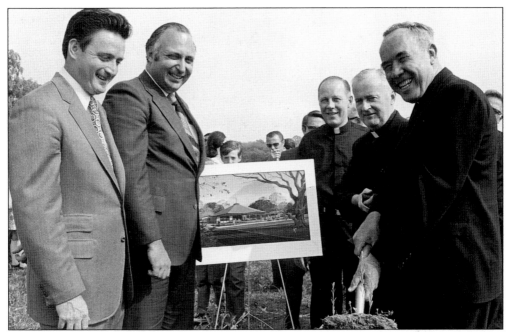

Marlboro's population growth made the 1878 church inadequate. After years of planning, ground was broken for the present St. Gabriel's at 100 North Main Street, south of County Road 520, on June 6, 1971. Wielding the shovel at the groundbreaking was the Reverend Walter B. Sullivan, associate pastor. Also present, from left to right, were Marlboro council president John J. McLaughlin, Mayor Morton Salkind, the Reverend Eugene R. Scheg, an associate pastor, who in 1982 became pastor of St. Catharine's, Holmdel, and St. Gabriel's pastor, the Reverend James T. Connell.

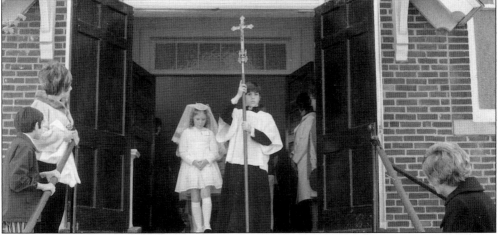

St. John's, a Roman Catholic church, was organized in 1921, opening in 1922 on the east side of Main Street, south of the home of John and Mary Holland, the church property donors. The church, which served the Marlboro village area into the 1970s, was deconsecrated in 1978 and sold to interests who remodeled the building as offices; their congregation was merged into St. Gabriel's. The shape of the front-gabled building, pictured at an early 1970s confirmation, is unchanged, but this entrance has been closed, while the door was relocated on the north, adjacent to a parking lot.

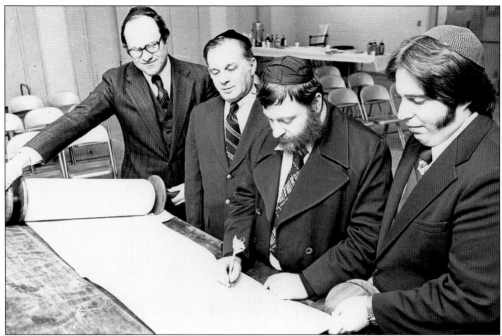

A Jewish ritual commandment directs each person to complete a Torah in his lifetime. Ray Kramer, then mayor of Asbury Park, second from left, is seen fulfilling that tradition on December 9, 1976, at Congregation Ohev Shalom (when it was meeting at the Marlboro Elementary School). Also present were from left to right, Rabbi Sidney Goldstein, Asbury Park, Rabbi Moshe Klein, Brooklyn, the scribe, and Rabbi Daniel Teplitz, the Marlboro temple's rabbi. Kramer donated the Torah in memory of his father, Samuel.

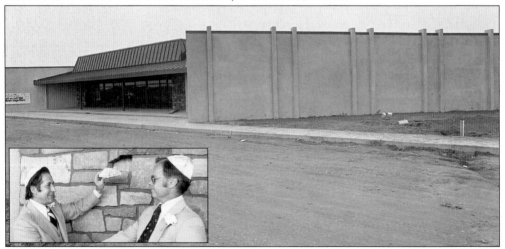

Congregation Ohev Shalom, founded in 1970, occupied temporary quarters before erecting the Marlboro Jewish Center, completed in 1977, on School Road West, near Wyncrest Road. The building includes a synagogue, a school wing, and catering-dining facilities. The building is pictured in June 1977; a sign on the facade and a new door on the side at right would be the only changes in this image today. Robert Kaldor, left in the inset, is seen about to place a stone from the Wailing Wall in Jerusalem in the facade on June 12, 1977, with George Harvey, representing the builder.

Five

COMMERCE AND TRANSPORTATION

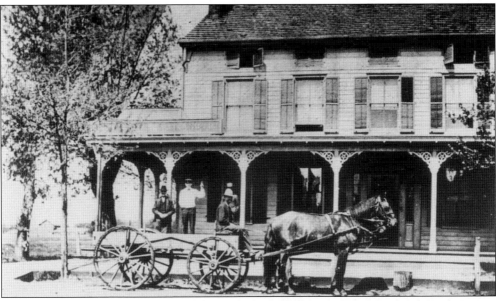

The Marlboro Hotel, built on the northwest corner of Main Street and School Road West in 1845, while Uriah Smalley was its keeper, was the second on the site with an earlier structure dating from some time in the 18th century. The unidentified wagon, seen *c.* 1910, probably belonged to a local, but the place was earlier a stagecoach stop. The building, alternately known as the Marlboro Inn, ceased being a hotel perhaps prior to 1920. It had been a gathering place, in its early days, a town center, and in a mid-20th-century incarnation, a hang-out as the Corner Sweet Shoppe. The place ended its hotel dates around the 1919 death of William A. Dugan, its last keeper. A vacant, deteriorating building was bought by the Marlboro Fire Department in 1995 and demolished the next year for expansion of their firehouse and parking area.

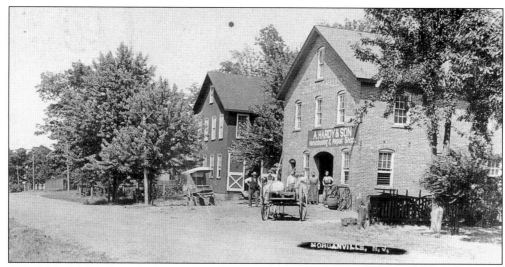

Alfred Hardy's blacksmith shop, pictured c. 1910 at right adjacent to John Dill's wheelwright shop, was located on the east side of Highway 79, north of Beacon Hill Road. He appears to have been one of the later-lasting blacksmiths, enduring into a decade that would see their numbers decimated through the emerging domination of the automobile. The origins of the perhaps c. 1890 building are obscure; not even its builder and first occupant are known. References to Liberty Hall are scant, but one infers it was a public meeting place (an ad for a dance there in 1898 was found), a not unusual second-story occupancy of business buildings. Hardy died at Morganville in 1942 at age 83. Lavoie Laboratories, a military supplier, later occupied the place; it has been vacant for many years. (Collection of Harold Solomon.)

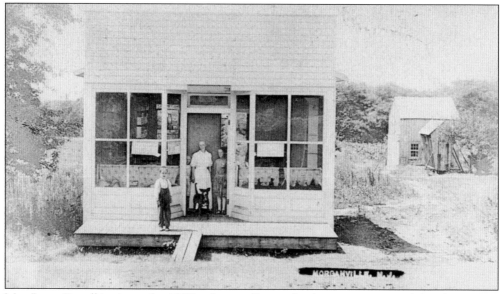

Mrs. James Farrell is pictured c. 1910 in her small store (with a vast expanse of glass for its time and type) on the west side of Tennent Road opposite the Morganville railroad station, with her children, pictured from left to right: Jerry, Marguerite, and Lillian. When her husband became postmaster in 1916, the store was the post office, perhaps in use throughout his tenure, which lasted into 1927. The lot is vacant today.

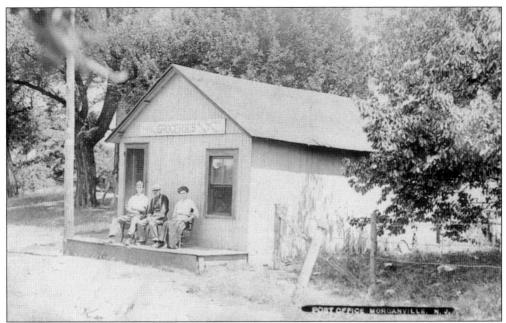

Johnson Woolley, center, was the postmaster from 1909 to 1916, using this store on the east side of Tennent Road (near Woolleytown Road and opposite the Little League field) as the post office. He sits with his wife Bess and Lou Heyer, posing around 1910 for Alick Merriman, publisher of the four photographic postcards on these facing pages. A woman named Della wrote to John Crine in South Carolina in 1911 on this example, reminding him of the hammock (at left) and inquiring of his desire to be there "now."

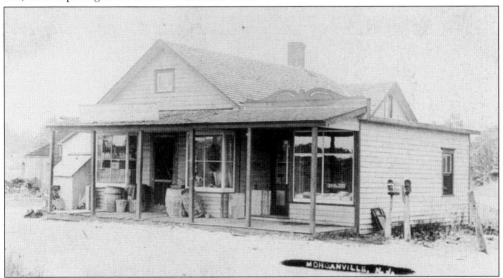

This Morganville store, at the northwest corner of Tennent and Spring Valley Roads, appears to reflect the early process of adding retail space to a dwelling. It was Harrington's when photographed by Alick Merriman c. 1910 for this photographic postcard, having been founded by a keeper named Honce. The store, later built up to two stories, had three apartments and pumped gas. It had deteriorated, and was at the juncture of a preservation crossroads eight decades later. See the bottom of page 101.

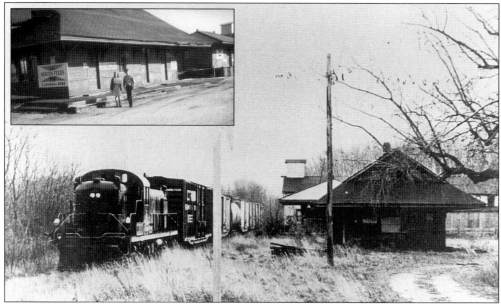

The rail line through Marlboro was organized in 1867 as the Monmouth County Agricultural Railroad and completed in 1877, after bankruptcy and reorganization as the Freehold and New York Railway. The Marlboro station, the southernmost of four in the township, was opened that year and rebuilt in 1892. A freight train is seen in November 1972, when the grounds were overgrown and the station was looking shabby. It was not in much better condition in March 1964 when young railroad buffs Kathy and Bill Longo (he is the author of Arcadia's *Hazlet Township*) visited.

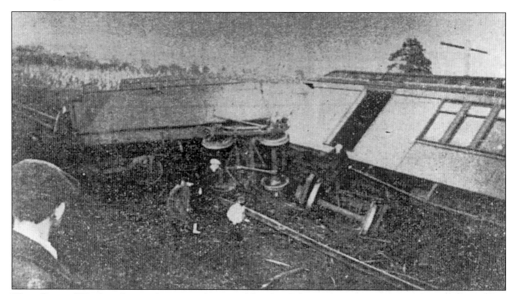

This Central Railroad train hit a truck owned by the Silvers Company of Cranbury on October 13, 1919. The engineer, Michael Mooney, 68, died from burns sustained from scalding, apparently from the boiler's water. The train's fireman, Fred Crotchfelt, and the truck driver escaped injury, but the truck was wrecked. The grade crossing—there were four near the village—was not identified.

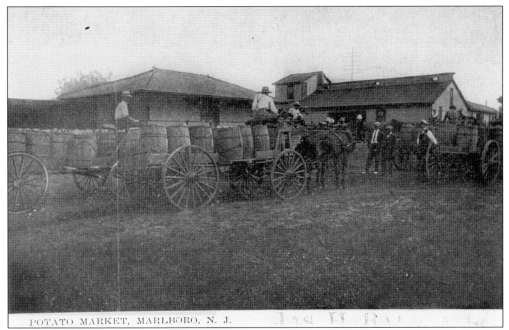

POTATO MARKET, MARLBORO, N. J.

Potatoes made up most of the rail business in the township. The building at right, pictured on a *c.* 1910 postcard, is a warehouse. Notice how warehouse owner J.H. Baird & Son sought to individualize a card issued as a town scene by a barely visible rubber-stamped insertion. Both buildings have been adapted for other commercial occupancies and are in use at publication time. (Collection of Harold Solomon.)

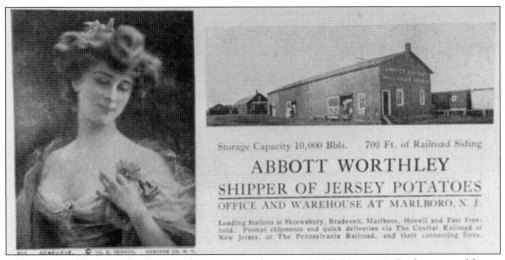

Storage Capacity 10,000 Bbls. 700 Ft. of Railroad Siding

ABBOTT WORTHLEY

SHIPPER OF JERSEY POTATOES

OFFICE AND WAREHOUSE AT MARLBORO, N. J.

Loading Stations at Shrewsbury, Bradevelt, Marlboro, Howell and Fast Freehold. Prompt shipments and quick deliveries via The Central Railroad of New Jersey, or The Pennsylvania Railroad, and their connecting lines.

Abbott Worthley bought the Baird station warehouse *c.* 1907. His *c.* 1915 advertising blotter caught the eye with a subject more appealing than the prosaic building, while its caption describes their operation. These photographs do not depict the lengthy frontage still visible at the site. No trace remains of the nearby Bradevelt warehouse. (Collection of John Rhody.)

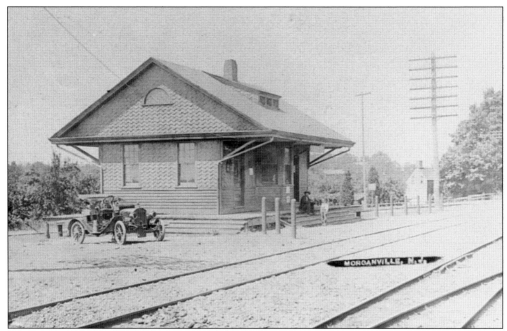

The Morganville station, located on the east side of Tennent Road about 200 yards south of Church Lane, was opened in 1877 and rebuilt around 1890. Pictured on a *c.* 1910 Merriman photographic postcard, the station was demolished in the early 1950s. Its lot, adjacent to a restaurant and the power lines' crossing of the road, is vacant today. (Collection of John Rhody.)

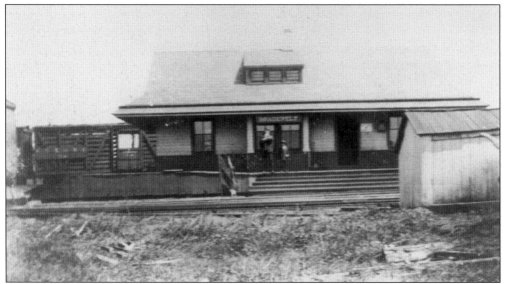

The Bradevelt station, opening in 1877, was initially named Hillsdale for the locality, but was switched in 1883 as the neighborhood needed a name change to accommodate a new post office, there already having been a Hillsdale in Bergen County. John Frawley, station agent and postmaster, is seen *c.* 1914 with a young Daniel Stattel, at the station built in 1894. A former coach was installed as a station in 1927; it was destroyed by fire in 1951. The site, between the Reformed Church cemetery and new housing, is vacant.

The future of the high, narrow bridge over County Road 520, pictured in 1974, an admitted safety hazard, was debated for some while in the 1960s and early 1970s. Although rail traffic had diminished, Marlboro mayor Morton Salkind favored a replacement bridge in lieu of a grade crossing. Eleven accidents, which included four injuries and one fatality, in the four years from January 1, 1963, heightened public concern. Rail operations ceased and the bridge was removed in 1974. The rails were also removed from the road, and the site, at a slight depression west of the Reformed Church, leaves no reminder of its former railroad crossing.

This Highway 79 scene, looking west towards Station Road (the site of the car) also provides a slight glimpse of the Wickatunk railroad station, behind the uglybillboard (which is really one word). It was opened in 1877, designated Cooks for John S. Cook, who sold the railroad the lot in 1871, and renamed in 1879; a new station was built in 1900, one that replicated the township's other three. The station, demolished in the 1970s, is seen in that decade via the inset. A house is now on the site. (Special Collections & Archives, Rutgers University Libraries.)

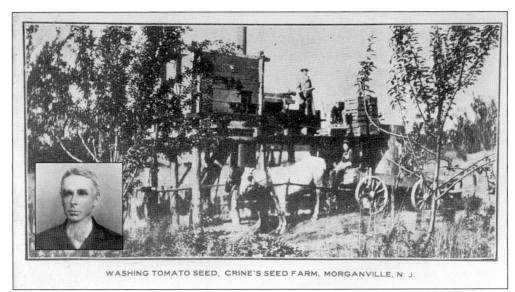

WASHING TOMATO SEED, CRINE'S SEED FARM, MORGANVILLE, N. J.

Michael Crine(inset), born in County Galway, Ireland, in 1838, emigrated to America as an eleven-year old, began work as a farm laborer, and bought his first farm in Morganville in 1863, 5.65 acres from Thomas S. Smith. His son Robert Vincent developed an interest in seed selection, beginning such work on a small scale on his father's farm. This rare c.1907 postcard depicts the early seed operation, although Vincent, as he was known, would develop other related interests. (Collection of Harold Solomon.)

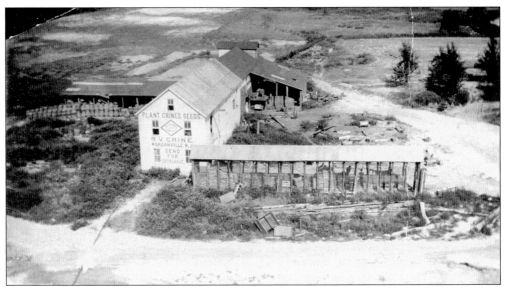

Vincent Crine's first factory was built in 1907. It may have been the two-and-a-half-story structure in the foreground of this c.1907 photograph, or perhaps that building was the dormitory Crine reportedly built for dozens of workers brought from New York. An expanding business soon required additional space and replacement of these crude open sheds. The photographer's elevated site is puzzling. The picture pre-dates Collier's aviation activities, so one wonders if it was taken from a balloon.

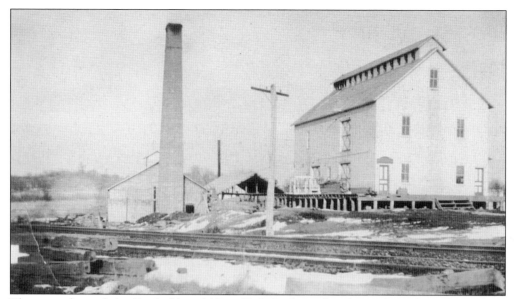

The main line of the Freehold and New York Railway (by then a branch of the Central Railroad) ran past the plant, which also had a rail siding through its property. This c. 1908–09 photograph shows a brick one-and-a-half-story storage building with another under construction (roof in the background). The building behind the larger structure (bottom page 90) had been removed. Crine also leased nearby greenhouses and grew, perhaps as an ancillary business, a number of crops on the hundreds of acres he controlled. He had been trading as the R.V. Crine Seed Company, but incorporated in January 1911, his investors including John H. Becker of Morganville and J.M. Grant of Chicago.

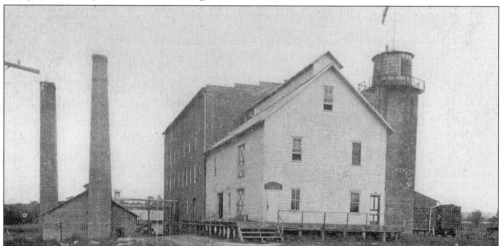

A large, brick four-story plant, built in 1911, is pictured on a c. 1911 postcard that reflects a scene still recognizable today. Crine's operation expanded to include ketchup manufacture and, it was reported, the processing of other foods. Crine's business, having taken a sizable mortgage and dealing in a business with swings in its market, became bankrupt. The factory was sold in 1916 and has been used by a number of oil and chemical occupants, at least by 1920 and continuing to date. A derelict shell of the tall brick building stands, while the others, in addition to later expansions, remain in use, reflecting various physical changes, including removal of the water tank and lowering of the chimneys. (Collection of Harold Solomon.)

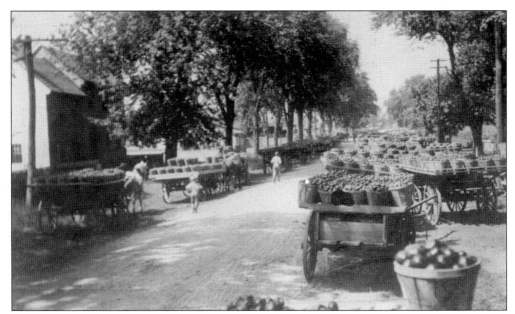

The site of this *c.* 1910 photograph, saved by a Crine family member, is not identified, but is attributed to Orchard Street, running west of Tennent Road to the Crine plant. The street fits by virtue of age of buildings and trees, the presence of utility lines, and the knowledge that long lines of farm wagons regularly gathered there in the busy season to deliver tomatoes to the factory. (Collection of St. Gabriel's Church.)

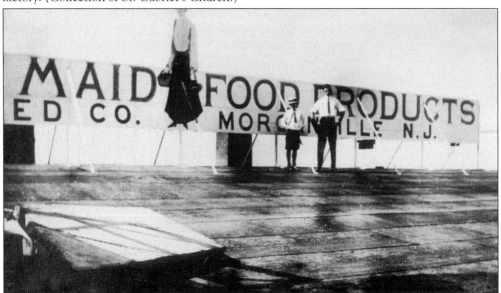

Crine began ketchup manufacture as an alternative to discarding tomato pulp in the seed extraction process. The separated pulp flowed to a basement storage well, was pumped to the factory's top floor for cooking in 22 copper kettles, each holding 250 gallons. Some cooked pulp was stored; the rest was bottled on the third floor. Four of Crine's five brands were made with the customary one-tenth of one percent benzoate of soda. The premium fifth brand, *Country Maid*, omitted the soda and was sterilized in special apparatus Crine first used for ketchup. John Kelly Crine is at right, father of the lender, Helen Crine Mahon.

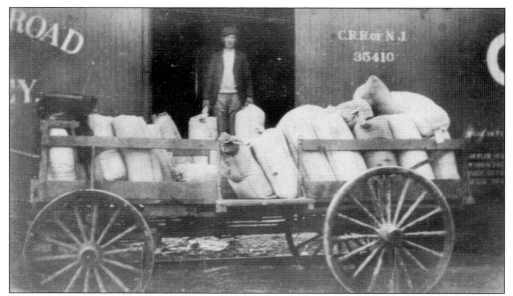

A rail photograph in a Crine family collection is a reminder of the railroad's importance to an early Crine business innovation. He sought to develop strains of tomato and potato that would mature earlier than existing varieties. Alternately, he conceived the plan to start seedlings earlier in warmer climates, beginning in 1911 at Yonges Island, South Carolina. He later moved to Cairo, Georgia, where he grew tomatoes and canned vegetables.

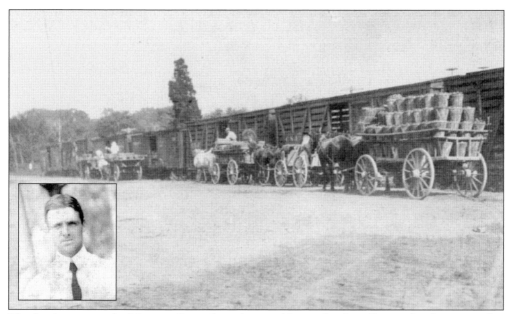

The final image in the Vincent Crine (inset) series (from a family collection) only suggests his later career. After obtaining a southern location to grow early maturing plants for New Jersey, he relocated to Georgia after the Morganville failure. He expanded business there to include growing and canning vegetables. Vincent helped develop and grow okra for Campbell's and aided their manufacture of their chicken gumbo soup, so think of Vincent if you ever open that variety. Crine died in Cairo, Georgia, in 1944 at age 64.

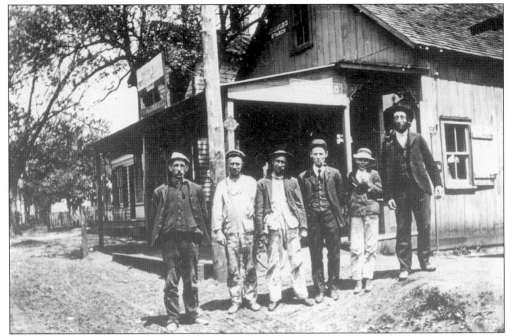

The six subjects in front of Frank T. Burke's store are unidentified, but the fourth from the left appears to wear a railroad uniform. The tall man at right seems huge by virtue of his standing on an elevation. The lot south of the store appears vacant, making one suspect the picture dates from shortly after the May 1901 fire that was stopped by tearing down the town hall adjacent to Burke's.

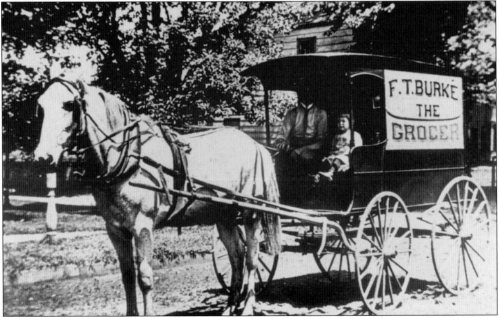

One suspects these are Burke family members in Frank's wagon, but the subjects are not identified. Burke the grocer offered the "right goods, right prices, right service" in an advertisement contemporary with this *c.* 1910 picture.

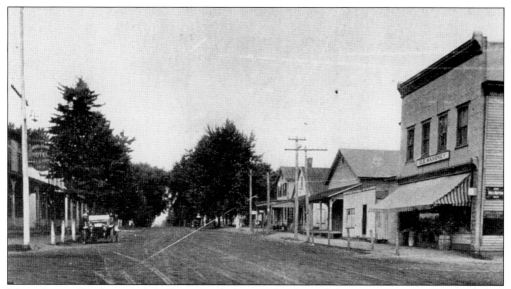

Main Street (Highway 79) looking north from School Road c. 1911 showed a new northeast corner as a May 1901 fire, which began on the south side of the corner, destroyed two grocery stores, one on either side of School Road, as the flames leaped across the street, and a blacksmith shop on the north side. The interior of D.E. Mahoney's store is pictured below during Charles McCue's ownership. A canopy in front of the Marlboro Hotel (see page 83) on the northwest corner is visible at left. (Collection of John Rhody.)

Charles "Spec" McCue, pictured c. 1950 at left with clerk Kenneth Conover, operated the Garden State Grocery Store at the northeast corner of Main Street and School Road East for 34 years dating from 1934. The shelves show both faded and familiar brands, although among the latter, Aunt Jemima no longer enjoys the prominence on the box as in the one in the upper left corner.

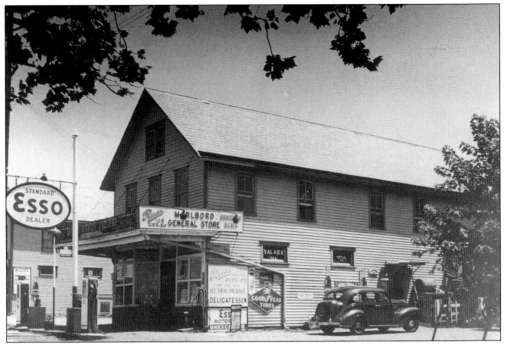

The Marlboro General Store, which stood on the southeast corner of Main Street (Highway 79) and School Road East, was built *c.* early 1900s, surviving into the 1970s. Pictured *c.* 1950s, the building was demolished in the 1970s and replaced by the one-story convenience store now on the site.

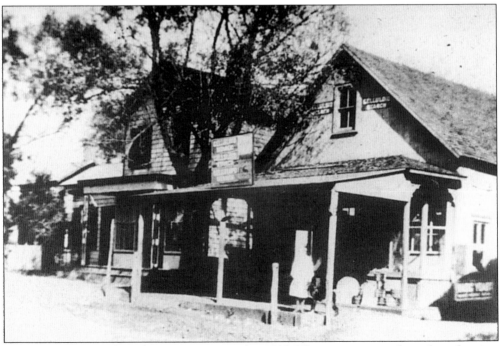

A closer view of Frank Burke's store is pictured *c.* 1910. The image appears later than the view on the top of page 94, but earlier than the one on the top of page 95.

The subject on this c. 1910 picture is attributed to James Henry Minkerson (identified by Ira Tilton, who knew him), village barber and local gravedigger. The view looks at the east side of Main, taken from outside the shop near the School Road corner he reportedly rented from Hobart. One wishes substantive information were available.

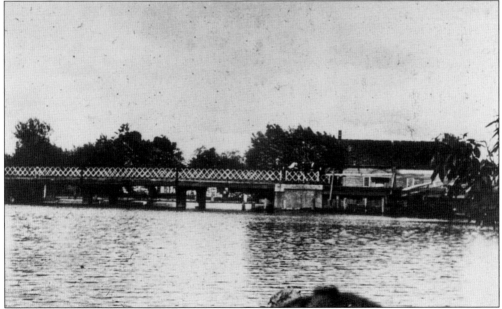

The gristmill on Big Brook, north of Marlboro village, east of Highway 79, perhaps had 18th-century origins. A mill was inevitable in farming communities during the early days when transport of grain was costly and difficult. A local mill's disappearance was also to be expected as regional milling centers, notably in the midwest, became the nation's granaries. The site, pictured c. 1910, appears vacant today; the time and means of the mill's removal are unknown.

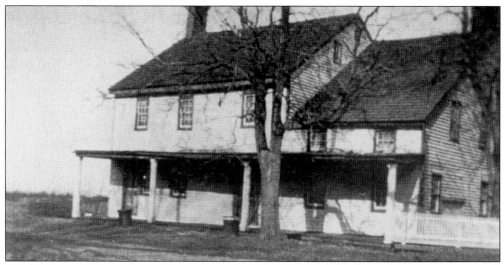

The Robertsville Inn was an old structure of uncertain age, but likely 18th-century origin, that long served as western Marlboro's public accommodations. It was a 21-room, double structure (presumably the section at right was older), with mud brick-lined walls, that was set on a 120-acre plot, standing on the northwest corner of Tennent Road and County Road 520. The bar, located in a first-floor living room, was removed around 1902 when the Smiths purchased the place from the Robertses. The Inn was gutted by fire c. 1964 and the remaining structure was torn down. Its site, still vacant, can be seen on the bottom of page 122.

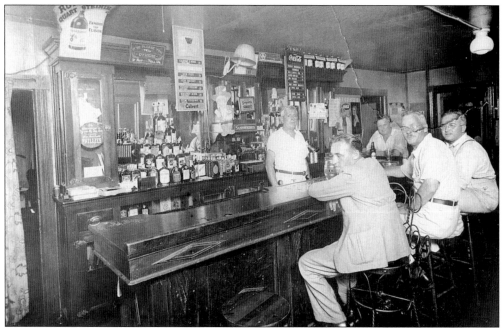

Harvey Cook operated a bar on the east side of Main Street during the 1930s at the fifth store north of the corner. He is pictured standing behind the bar. His customers, clockwise from the rear, are an unidentified man, Charles McCue, Walter Heiser, and a seemingly unhappy Charles Cummings. If one did not get enough by closing time, the pint bottles at left would fit conveniently in the pocket.

"Where Your Appetite is Always Satisfied"

Julia and Joe Rocco opened this roadside eatery in the early 1950s on the west side of Highway 9, near the present Windsor Gardens. Some of the area's best burgers and steaks were served on a large, round counter surrounding a charcoal pit. Julia's was known as a fine place to drop-in after one's night-out, as they had a liberal 2:30 a.m. closing time. The restaurant was destroyed by a fire, "cause unknown," in 1962, about two years after the Roccos sold it. (Collection of Harold Solomon.)

The distinctive chicken sign and the odd spelling in The Chicken Koop, pictured c. 1950, are other reminders (in addition to Julia's) of the times when roadside food stands sought singular character rather than franchise sameness. They "specialized" in chicken-in-the-basket (although it appears that everyone did then), seafood, and steaks. The building still stands at 158 Highway 79 (north of County Road 520), altered, but recognizable, housing a pre-school. (Collection of John Rhody.)

Roy S. Tilton, New Jersey salesman for dairy equipment supplier Babson Brothers of Syracuse, New York, opened his own supply business in 1942, while remaining with Babson. He is pictured around that year on the east side of Main Street, with his two sons, J. Edward, center, and Roy Jr. The younger Roy ran the firm's branch operation in Andover, New Jersey.

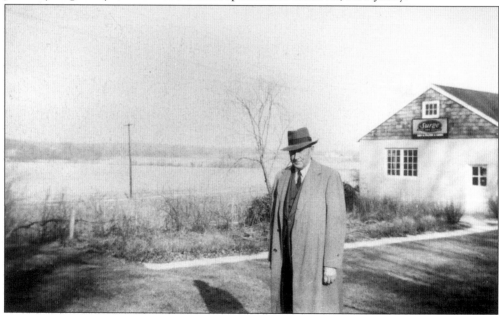

Roy S. Tilton is pictured c. late 1940s in the foreground of the barn at 33 Hudson Street. His firm also sold hardware, paint, water pumps, and tractors, using the pictured building for servicing the latter. Dairy equipment was the key line, however, so falling demand resulting from the consolidation of the local dairy industry led eventually to the demise of the business. The building still stands, with a later addition.

This corn dryer was photographed when new in 1951, reflecting still-thriving agriculture in Marlboro. It was photographed looking northwest towards the corner of Railroad Avenue and Orchard Street, where the garage at right still stands. The tile towers remain, their roof and machinery gone. (The Dorn's Collection.)

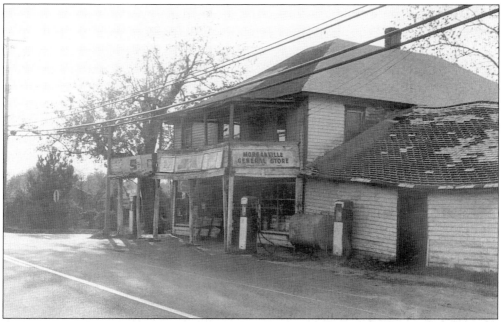

The Morganville General Store at the northwest corner of Tennent and Spring Valley Roads, seen on the bottom of page 85, was preserved under the ownership of Frank Martucci. The ell was removed in 1989; the pumps are gone, small store gas retailing having fallen out of favor during the 1970s gasoline "shortages." Martucci, from Staten Island, indicated Morganville reminded him of that county before its bridge connection to Brooklyn urbanized the place. The refurbished store still stands, an up-to-date reminder of the old days.

The former general store in Wickatunk was built in 1927, housing the post office in the early 1930s. The place was later converted to the Wickatunk garage, operated by the Janwich family until Norman Janwich's retirement c. 1990. The stucco-clad tile building is pictured in 1973, prior to receiving the brick facing now visible at the building, vacant at the August 1999 publication date, at 239 Highway 79.

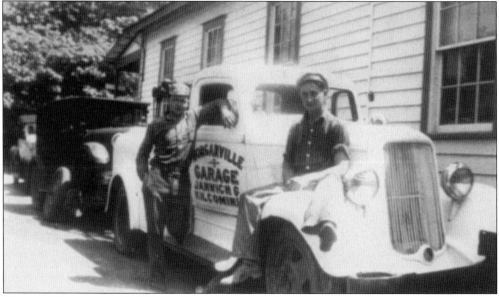

Wilmer Kilcomins and William Janwich owned the Morganville Garage at 425 Highway 79 at Harnley Road, but Hank Holtz, left, and Hank Hanaway were photographed there in June 1940. The still-standing building had been used for storage, but again houses an automotive trade.

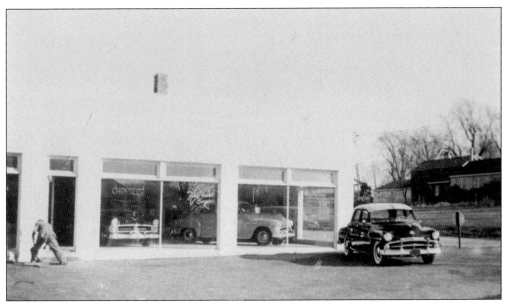

Bennett's garage and service station was remodeled into an automobile showroom in 1935. The building at the northeast corner of North Main Street and Bucks Lane is pictured *c.* 1951 after a later expansion. The building is still recognizable, although the doors and windows have been rearranged and a decorative addition placed on the roof.

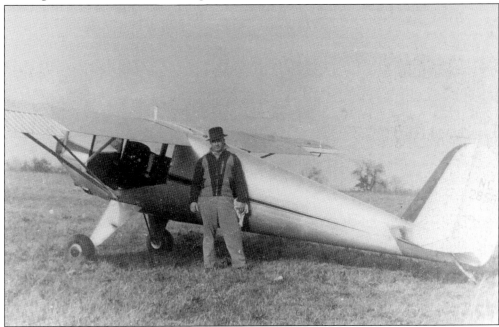

Rhea Preston, born 1912, first flew as a 20 year old, figuratively as a lark, when a friend offered a "ride" to Roosevelt Field, Long Island. Rhea returned enthused and began lessons with Fred Allgor in Keyport, Monmouth County's first aviation center, at $5 per hour. He is pictured in 1939 with his first plane, that year's Luscombe Silvaire, manufactured in Trenton, which he recalls as "one of the most beautiful airplanes built." A flat section of the Preston farm was used for taking off and landing.

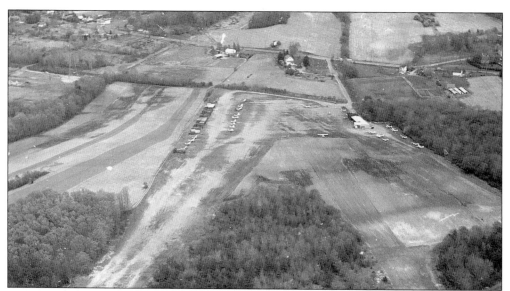

Rhea sold the Silvaire, as he left for World War II service in the Navy, but returned with flying enthusiasm intact, and in time, he developed the desire to build his own airport on about 44 acres of the farm. Although the airport plan was not fondly embraced by the township, Rhea persevered through the regulatory process and, in the absence of prohibitions, secured the necessary licenses in 1954. This 1950s picture shows the runways as grass strips; Highway 79 is in the background. Rhea attracted a number of aviators from the Keyport airport, as it was closing, and personally flew in two planes from Red Bank.

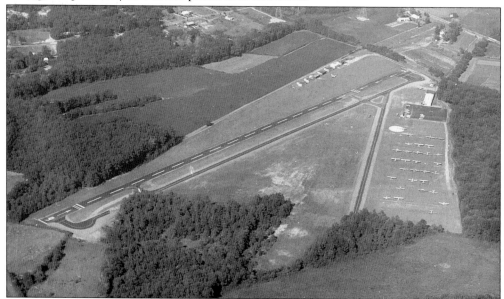

This mid-1970s photograph by Jack Lentz shows the same basic contours of the field, by then paved and with the runway realigned. A grass runway creates the hazard of kicking up stones, which can readily ruin a propeller, but they are more forgiving of pilot error than pavement. Rhea sold the airport to Everett Fenwick in 1972, recalling recently that the airport ambiance was akin to "one big family," but it was also a lot of work and not particularly profitable. Ownership is expected to change, as recent owner Leonard Genova died in 1999.

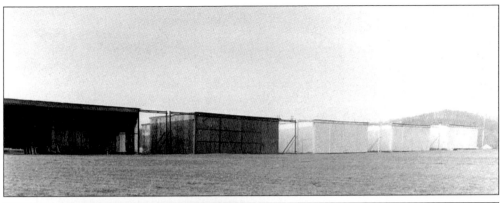

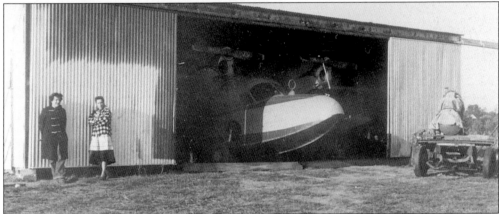

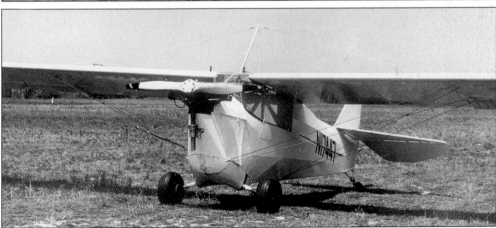

Rhea Preston built the first seven T-shaped hangars (top) by moving them from the former airport at the present Forsgate Country Club in Monroe Township, near Jamesburg, Middlesex County, paying $100 each for two-year-old structures that he recalled were $3,000 installed new. A large hangar was built in 1958. Van Winkle Todd's Navy Grumman J4F "Widgeon" seaplane is peering out of one of the hangars (center). At left is a Todd daughter, together with Rhea's wife Aileen. One of the more unusual planes at the Marlboro Airport was an early two cylinder Aeronca C-2, which developed all of about 30 horsepower. It is an early model of a short production run (bottom), seen on the ground, a preferred location in some aviators' minds as its marginal power did not inspire flyer confidence in its air worthiness.

Roadside retailing at the beginning of this century was a small store, at times a stand-alone expanded house or other tiny building (page 85), or a cluster in a village (page 95); at the century's end, the strip shopping center is ubiquitous. The stores at Highway 79 and Tennent Road, seen when new in January 1975, still stand, a veritable village in their own right.

Kathy Willey Hruszczak (now Raymond) founded a service-oriented business in Marlboro in 1984, A Pet's Preference, which address both contemporary busy lifestyles and the stature of the pet as a full-fledged member of many American families. It is a mobile cat and dog grooming service, performed in a specially equipped van that visits the pet owner's home. Kathy, a business management graduate of Trenton State, is seen in the business' early days drying a cat.

106

Six

PUBLIC LIFE AND ORGANIZATIONS

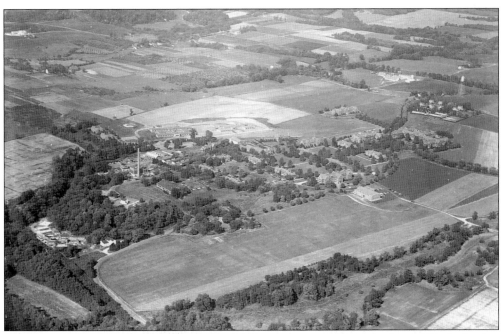

The State of New Jersey assembled a plot of 411 acres, principally in the late 1920s, by buying farms, paying at that time around $150 per acre, for the building of the Marlboro Psychiatric Hospital. Construction began in February 1930, with structures concentrated on about 25% of the plot, which borders County Road 520 on the south, the former railroad on the west, Conover Road on the east, and privately owned land on the north. This aerial was taken in September 1957 as major construction was about to begin on a new building for seniles, planned to accommodate 280 patients. (The Dorn's Collection.)

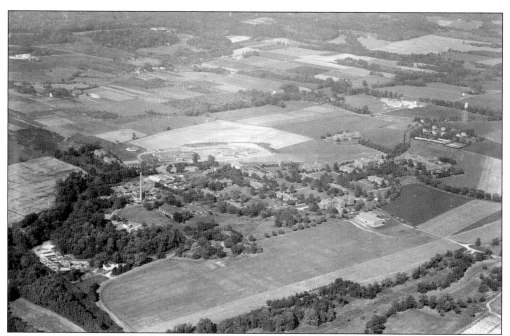

This hospital is seen in the context of surrounding farms in 1957. The taller structures were the power plant at left and the water tower at right. Security issues for the facility were long a local concern. State mental health practice in the 1990s focused on getting patients into "community settings," with a reluctance to maintain costly in-patient hospitals, regardless of the ongoing need. (The Dorn's Collection.) ✳

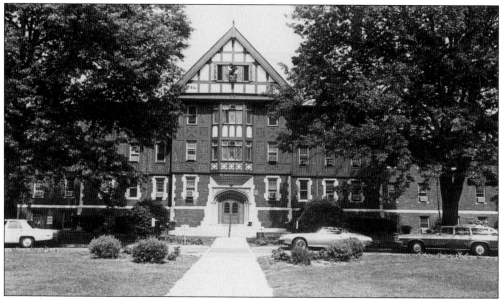

The hospital's administration building reflects the Tudor Revival architectural style in which most of the original structures were designed. The hospital closed in 1998 and has since been the subject of many proposals for its reuse or development or preservation of the site's open space, subject to the constraints of the Marlboro Agriculture Land Conservation District. The site's future is one of Marlboro's greatest public issues at the late 1999 time of publication. ✳

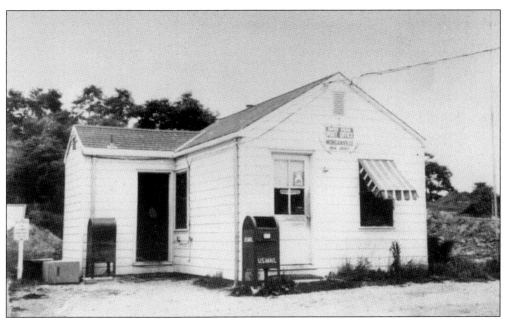

The Morganville post office was established in 1870; its space in its early years was a succession of stores (see pages 84–5). This small structure became the first stand-alone office during the tenure of postmaster Lillian F. Slover, who served from 1947 to 1951, erecting the building, perhaps in the late 1940s. The building stood on the east side of Tennent Road, opposite Woolleytown Road, in the driveway of the present post office, until the new building was completed in 1963.

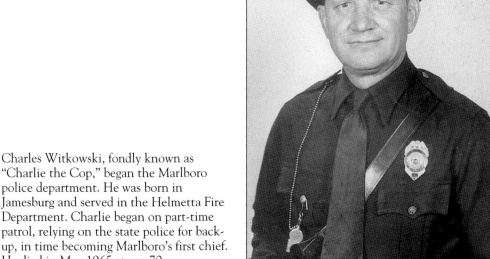

Charles Witkowski, fondly known as "Charlie the Cop," began the Marlboro police department. He was born in Jamesburg and served in the Helmetta Fire Department. Charlie began on part-time patrol, relying on the state police for back-up, in time becoming Marlboro's first chief. He died in May 1965 at age 70.

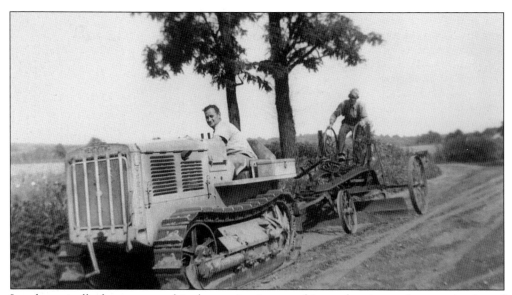

Locals, typically farmers, were hired to maintain township roads prior to the organization of municipal public works departments. This road-scraping scene in June 1942 pictures William Holmes in the treaded tractor, with Clyde Vreeland Ronson on the scrapper, seen on Nolan Road in front of number 62.

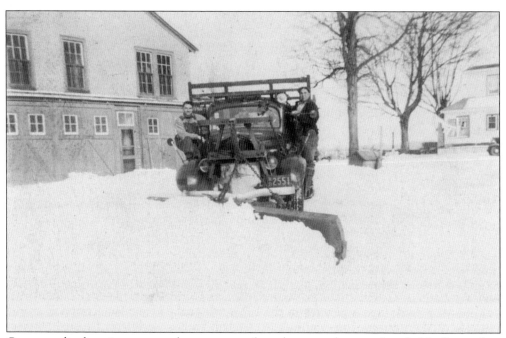

Correspondingly, winter snow clearers were often the same farmers. Joseph Meglio used to perform that service for Marlboro.

Howard J. Preston, son of William, born in 1898, had a long, distinguished record of public service, both in county employment and in volunteer capacities. He began a 30-year career with the Division of Highways in 1936, serving as supervisor for the last 20, overseeing a substantial growth in county road mileage, equipment, and personnel. Innovation marked Howard's tenure. Many changes were technical, but one, the first paint highway dividing stripes, has an ongoing, visible safety value. Another, his "Sno-go" machine kept winter roads clear in the era prior to massive machinery. Howard was a key figure in the Monmouth Republican organization, serving on the county committee for 30 years and was a president of his Rotary club. He also served Marlboro Township as registrar of statistics and tax assessor for 35 and 31 years respectively. Howard and his wife, the former Mabel Stattel, had one son, Howard D. Howard J. died in 1970.

The township committee is pictured in the late 1950s at the former municipal hall on the east side of Main Street. They are from left, seated: Lindsay Le Moine, Leonard Nivison, Charles McCue, Frank Ratcliffe, and Joe Lanzaro. Floyd Wyckoff is standing at right, next to an unidentified man.

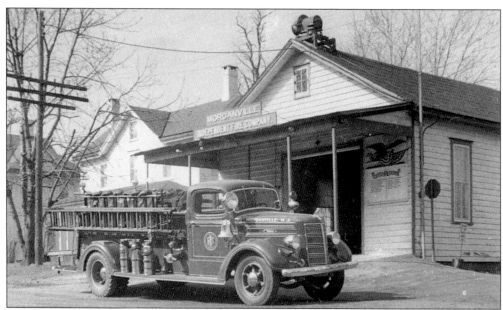

Marlboro's third fire company, Morganville Independent, was founded in 1916, a little more than a year after the formation of Morganville Volunteer Fire Company No. 1. They moved the former Morganville school (page 67) to the west side of Highway 79, adapting it for a firehouse, expanding it later, perhaps c. 1950s, and later moved it south on Highway 79 to its present location. Their 1940 Mack is seen in the early 1940s parked outside the southwest corner of Highway 79 and Harnley Road, a site recognizable today by the presence of the unchanged house, number 423, at left.

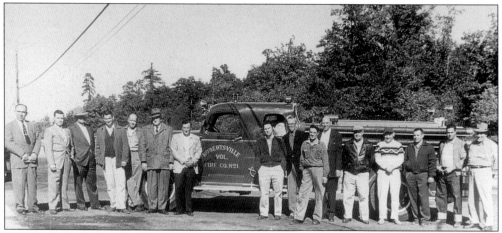

The travel distance required by other township fire companies to serve Robertsville motivated the community to form its own company in 1958. The members, who initially met in the Robertsville school, are seen that October with their first apparatus, a 1941 GMC pumper. They are, from left to right, Frank Rappa, Frank Boyce, Howard Preston (who was not a member, but advanced them $3,000 to purchase the truck), Everett Storer, Vincent Schreck, Leonard Nivison, Alfred Storer, Charles Keck, Robert Nivison (donor of the photograph), Mack McAllister, Edward Bordeman, Arthur Daley, Fred Bayer, Herbert Lowen, Franklin Emmons, and Albert Boysen. The truck was initially kept in Frank Boyce's garage until the first two bays of the present firehouse on County Road 520 were built c. 1960.

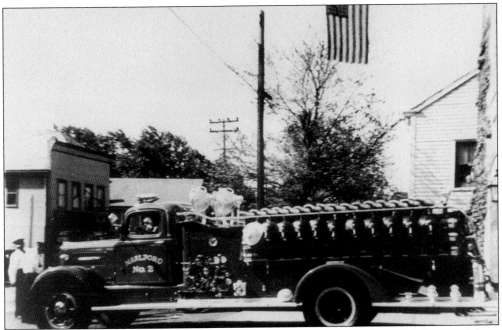

The Marlboro Fire Company was incorporated in 1908, seven years after a fire destroyed three shops on the corner of Main Street and School Road East. They occupied an old building near the northwest corner, which was demolished in 1933 prior to the construction of the present firehouse, which was described at the time as "up to date in every detail and one of the finest firehouses of its size in the state." This c. 1950 photograph provides only a glimpse of that building at far right. However, it shows good partial views of the hotel adjacent (page 83) and the McCue store (page 95) above the hood of the engine.

Marie A. Muhler's public service began with the Marlboro Board of Education and the Marlboro Board of Adjustment, as well as a variety of volunteer positions. She was first elected to the New Jersey Assembly in 1975 (and is pictured during that campaign), winning re-election for a number of terms. Mrs. Muhler now serves as the Surrogate of Monmouth County.

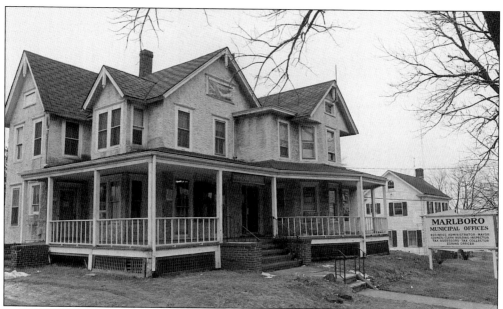

The former Floyd Wyckoff house at 33 North Main Street is pictured in February 1975 as the township, which purchased the building in the 1960s, planned to move its municipal offices, claiming the deteriorating building was in danger of collapse. The place was rehabilitated and still stands, occupied as offices. Vinyl siding now covers the stucco, while a major addition was placed on the north. The house at right, number 35, is now occupied by shops.

Although Marlboro had small township halls from the late 19th century, Mary Denton, township administrator, recalled in 1975 that many employees worked out of their houses when she became deputy clerk in 1966. The Marlboro Township leased two of the nine buildings in a strip shopping center at Route 79 and Tennent Road. This was a provisional measure as plans for a new municipal complex were being aired as township offices moved during the spring of 1975.

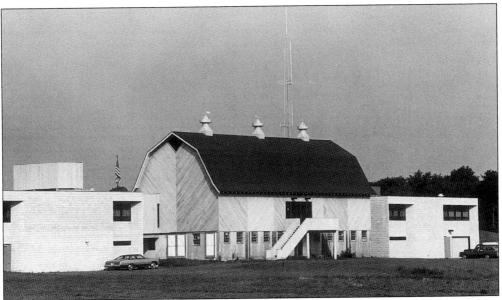

H&L Farm, which bred prize black Angus cattle, was sold to US Homes during the 1970s building boom. After construction of housing on the site was constrained by zoning regulations, part of the property was donated to the Township. Proposals for the municipal complex first made in 1975 were delayed for application for Federal funds, secured in the amount of about $250,000. Construction began around 1978 for the project that would cost over $2.3 million. The former barn is pictured in August 1979.

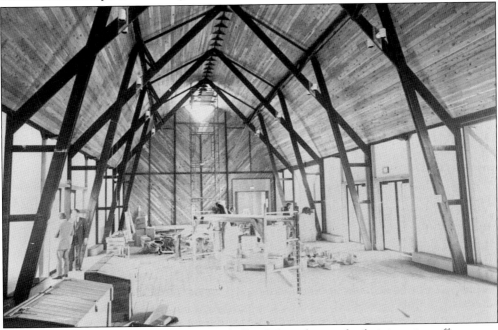

The barn was fashioned into a meeting hall, while police and administrative offices were constructed on the sides. Work is pictured nearing completion in early April 1979. The facility opened a month later. The site was planned for its central locale amidst municipal fields, the middle school, educational administrative offices, and the library.

A newly elected Saul Hornik looked forward to serving Marlboro as mayor, when pictured with his family in December 1979. He is seen with Nance, his wife at the time, and their children, from left to right: Melissa, Adam, and Jonathan. Adam, who died in 1997, loved Marlboro and "practically grew up in township offices." Saul takes pride in having stabilized the tax rate, while controlling growth during his 12-year tenure as mayor. His administration was also marked by an expansion of municipal services, a strong recreational program, and vigorous action in caring for the environment. Saul still serves in areas of special concern, such as environmental action and planning matters.

The township's celebrations of its 125th anniversary included breaking ground for its library, part of the Monmouth County system, on Wyncrest Road, at County Road 520. Mayor Morton Salkind turned the first shovel of earth; also present were, from left to right, unidentified, and councilmen Lawrence Grossman, Howard Klau, and Richard Kaplan.

Planning the township's municipal center was a long, loud process that centered on cost and site selection. After about six years of debate (argument may be a better word) and deliberation, ground was broken in October 1977 for the conversion of the H&L Farm on Wyncrest Road to municipal use, as seen on page 115. Present then were, from left to right: councilmen Richard Vuola, Howard Klau, and John Croddick, Mayor Arthur Goldzweig, Assemblyman Walter J. Kozloski, business administrator Mary Denton, and councilman C. Douglas McClung.

Marlboro's bicentennial celebrations included the governing body's "founding fathers night" on May 27, 1976. Dressed in colonial garb (which might make some think twice about seeking elective office) and discussing issues of the day (1776) were, from left to right, Councilman C. Douglas McClung, Mayor Arthur Goldzweig, Council President Lawrence S. Grossman, Councilman John F. Croddick, and township attorney Herbert B. Bierman.

Present for the dedication of the Marlboro Country Park in August 1975 were, from left to right: Joseph Eisenstein, parks chairman; Stanley Bauman, recreation chairman; Mayor Arthur Goldzweig; Helen Scafidi, township bicentennial chairman; Assemblyman Walter J. Kozloski; Assemblyman Morton Salkind; Stanley Young, chairman of the swimming pool division; and Stephen Hoch, director of the Department of Recreation and Open Space. The park, surrounding the Marlboro Swim Club, contains a number of recreational facilities.

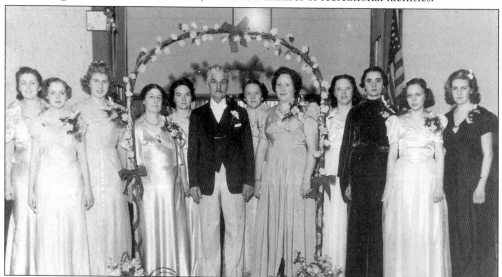

The Grange was an association of farmers founded in 1867, organized by local lodges; its members joined for a variety of social and advocacy purposes. Marlboro's Liberty Grange, founded in 1876, acquired the former Baptist church in the early 1940s. A group was pictured there in that decade, probably at an installation ceremony for a women's branch. They are, from left to right, Helen Clayton, Mildred Clayton, Myrtle Phillips De Forest, Carrie Willet, Mary Crine, Ruliff Willett, unidentified, Alma Dobbins Boyce, Nellie Woolley Wenzel, Jane Diggin Wendel, Ethel Woolley Probasco, and Barbara Graham Patterson.

118

Seven

AROUND TOWN

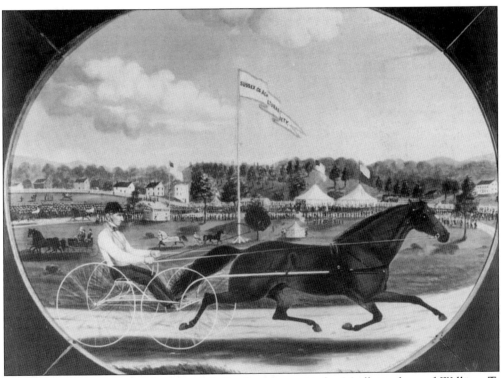

The champion standardbred *George M. Patchen*, born on the Marlboro farm of William T. Sickles and named after a New York City newspaperman, first excelled as a three year old in Freehold. His achievements there were so great that the Monmouth County Agricultural Society's course came to be known as the "George M. Patchen track." In 1859, Patchen ran a 2:23 mile, a world record for trotting stallions. The image is a painting by Charles Spencer Humphreys (1818–1880), a New Jersey artist who specialized in equestrian subjects. Patchen died in 1864 and was buried at the track in Woodhaven, Queens, New York, the site of the record-breaking run. (Collection Monmouth County Historical Association.)

Marlboro village is the barely discernible cluster of tightly packed buildings at top center, from which Vanderburg Road runs an irregular course to the bottom, at right. The c. early 1970s aerial shows Marlboro High School in the upper right corner. The railroad is a dark line across the picture, near the top. Boundary Road runs across the bottom. The earth appears disturbed where Route 18 will be at left, making one wonder if work had begun near its future Route 79 entrance. The house in the light field at right, near the center, is the Buck farm, which is undergoing extensive development at press time.

Route 79, still possessing the character of a quiet country highway above and below Marlboro village, has a divided, super-highway stem south of it, at the entrance to Route 18. How did that section appear previously? Like a quiet, country highway, as in this 1969 view south from the two roads' present juncture. The Werbler farm's (page 34) fine egg sign left no doubt of their product.

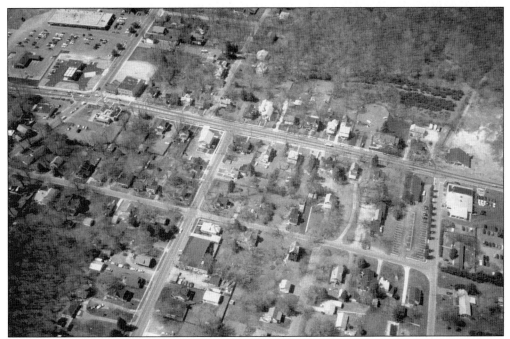

Main Street runs across the top, while Vanderburg Road is the wider of the east-west streets in this aerial view of Marlboro village. It is from the recent past, but dates prior to the destruction of the old hotel at the northwest corner with School Road (upper left). Hudson Street runs parallel with Main, while Bucks Lane is the east-west street at right. (Photograph by Lora Tilton.)

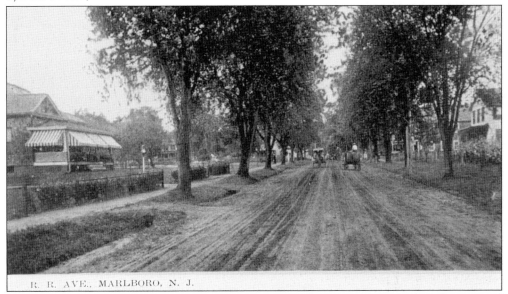

R. R. AVE., MARLBORO, N. J.

The scene looking west from near the station was Railroad Avenue in 1910 when this postcard was published. However, the street today is Vanderburg Road, the fourth name of a thoroughfare known earlier as Herbert Street and Orchard Street. This streetscape has been disturbed by many changes in the structures and removal of most of the trees. (Collection of Harold Solomon.)

Lloyd Road is so heavily trafficked at the time of publication, it may seem unlikely that it was a quiet country path in the1950s. The scene looking east was photographed from in front of number 60; the Doyle apple orchards, later the schools (page 70) that evolved into CPC Behavioral Healthcare, are seen in the background.

Tennent Road, pictured in 1969, was long a major north-south road and is still a well-trafficked secondary highway. In 1999, the intersection with County Road 520 is wider and busier, especially with the Highway 18 ramps now only a short distance to the east (left). The Robertsville Inn site is the northwest corner, in front of the car.

The unappealing image of an automobile accident is often the only surviving reminder of the former character of "ordinary" road scenes. This 1968 view north of Highway 79 shows the County Road 520 intersection prior to the construction of the Marlboro Shopping Center strip. The restaurant site is now occupied by a bank. Note the roadside telephone booth, a once-common structure which has virtually disappeared.

Newer residents may have a difficult time imagining traffic on County Road 520 at Highway 79 controlled by a mere stop sign, a spot now with three east bound lanes, the direction of this 1968 photograph. Meglio's farm, located east of today's Marlboro Shopping Center, can also be seen on pages 32–3.

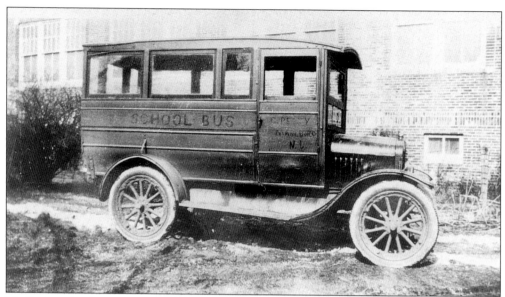

Marlboro school transportation began *c.* 1924, timed with the opening of the new village elementary school (page 71). A bus body was placed on a Ford Model T, which the picture lender, Jeannette Thompson, recalled was driven by Clarence Petty; it carried 12 students from the township's southwestern section, who were placed outside the two-mile distance transportation threshold by virtue of the school's relocation east on School Road.

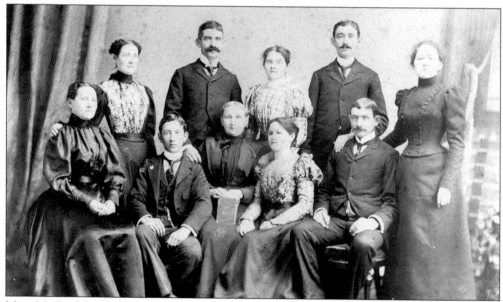

Mary McCue, the elderly woman seated in the center, was pictured *c.* 1890s with the widow of Irish immigrant Martin McCue, together with her children. They are, seated, to her right, Jane Diggins and John McCue; to her left are Clara Freeman and Patrick McCue. Standing, from left to right, are, Katherine Dugan, Martin McCue, Sally Collins, Thomas McCue, and Mary Hoffman. The younger Martin, a Marlboro native, bought a township farm after he founded a successful dairy in Long Branch.

The Tilton children were not about to operate this hand car in their Sunday attire, but the 1950s picture affords a glimpse of the west side of Highway 9 site of Callaghan's Pine Creek Railroad (inset). The recreational line with real equipment was sold *c.* 1961 and moved to Allaire State Park, where it continues in operation to date. This site is now the Pine Creek Square shops. Edward and Emily Tilton's brood includes, from left to right, twin daughters Lora (also see page 4) and Amy, and son Douglas.

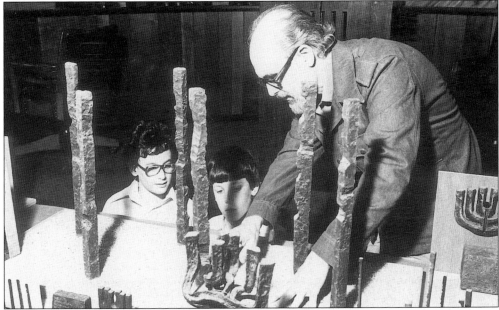

Marlboro architect and sculptor Emanuel Milstein studied architecture at Montana State College and later elsewhere, including in Paris through a government grant. He is pictured in April 1980 with Andrew Ohrwasel, left, and Andrew Udell during an exhibition of his work at the Marlboro township hall. This example is a model of a holocaust memorial titled "Memorial to the Six Million." Synagogue interiors are Milstein's architectural practice specialty. He has sculpted a number of holocaust memorials, having examples installed at New York, Long Island, Tennessee, and the District of Columbia. The latter, a 1962–63 work installed in a synagogue, is one of the first such memorials in this country.

Brown Road viewed looking west from the Eden Farm windmill was a pastoral scene in the early 1930s. This stem of road is still unpaved! The Glengeran Pond on Texas Road, pictured in the late 1930s, is a reminder of the time when the "old swimming hole" was the more likely site of water recreation rather than today's ubiquitous swimming pool.

Burnt Fly Bog, a woodland well in excess of 1,000 acres that spans the Marlboro-Old Bridge border, was long well-regarded for its recreational potential. The area is largely dry, with the Englishtown aquifer (effectively an underground river), a body with extensive water supply capabilities, creating the bog. Its plant life is notably rich, containing some rare varieties. Discovery of contamination, disagreements over the extent and its measurement, the preferred means for cleaning it, and apportionment of the enormous cost potential have mired the bog in a morass of accusation and inaction. This picture is dated August 1972.

Morganville Republicans hosted Congressman James Auchincloss at an October 26, 1960 event at the Morganville Independent firehouse. He is dressed in the three-piece suit. To the congressman's right are, from left to right, Gladys von Rodeck, Howard Preston, Bessie Wendel, Robert Nivison, and Beatrice Bond. To his left are Eleanor Diedloff, Lester Bond, and an unidentified man.

The County Route 520 crossing of a tributary of Willow Brook, a border with Holmdel, is a second reminder of "how many accidents does it take to replace a hazardous bridge." Two good drivers could easily cross together in opposite directions. However, the "One Lane Bridge" sign could make one uncomfortable, fearing the inevitable if one driver stuck to his half of the pavement, while an opposing driver believed the sign entitled him to the middle of the road. This steel truss bridge was replaced by the present concrete bridge in the mid-1980s.

Clockwise from upper left are, Ola Bidwell Sherry, who taught music in her Morganville house and the Keyport schools; Marilyn Grubb, modeling a black traveling dress and feather hat in 1983 at the house on the bottom of page 49, for an Old Brick Reformed Church fashion tea; Helen LeMoine Guth, who helped make sweet the Corner Sweet Shoppe, c. 1950s, before "shoppe" (pronounced "shop-pee") became the province of cutesy-smartsy retailing, especially in The Country; and Virginia Bruce, a nurse who became Marlboro's first female firefighter with Morganville Volunteer Fire Company No. 1.